goblinoids

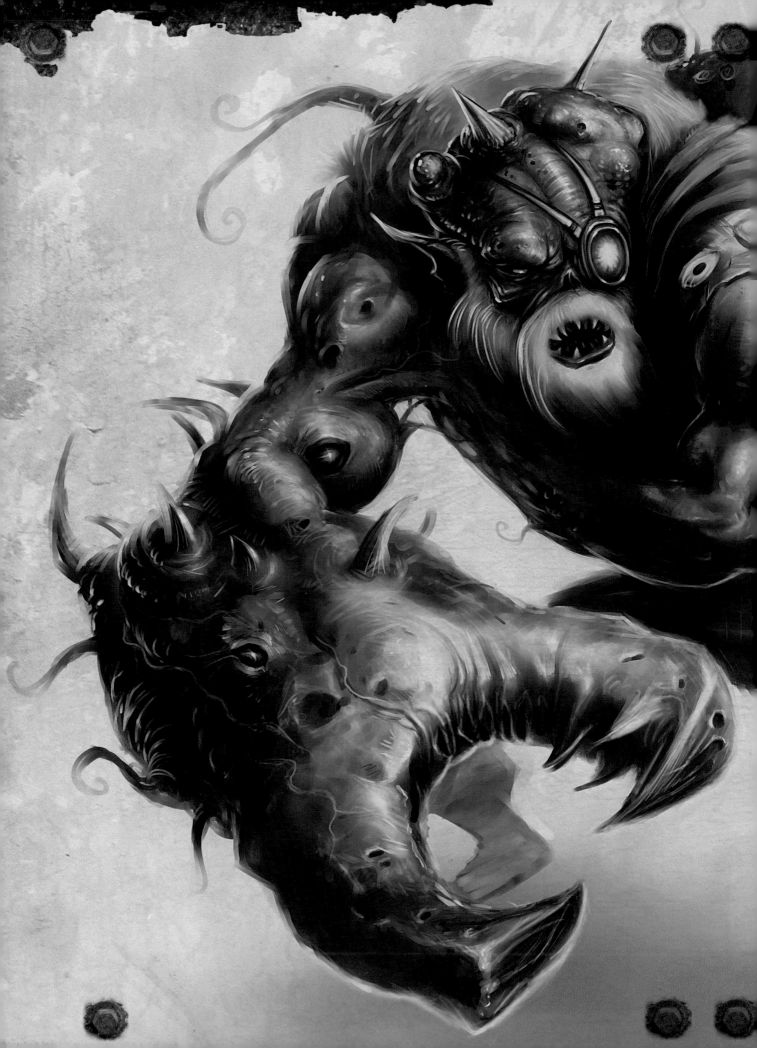

scott purdy

goblinoids

How to Draw and Paint Goblins, Orcs and Other Dark Creatures

IMPACT

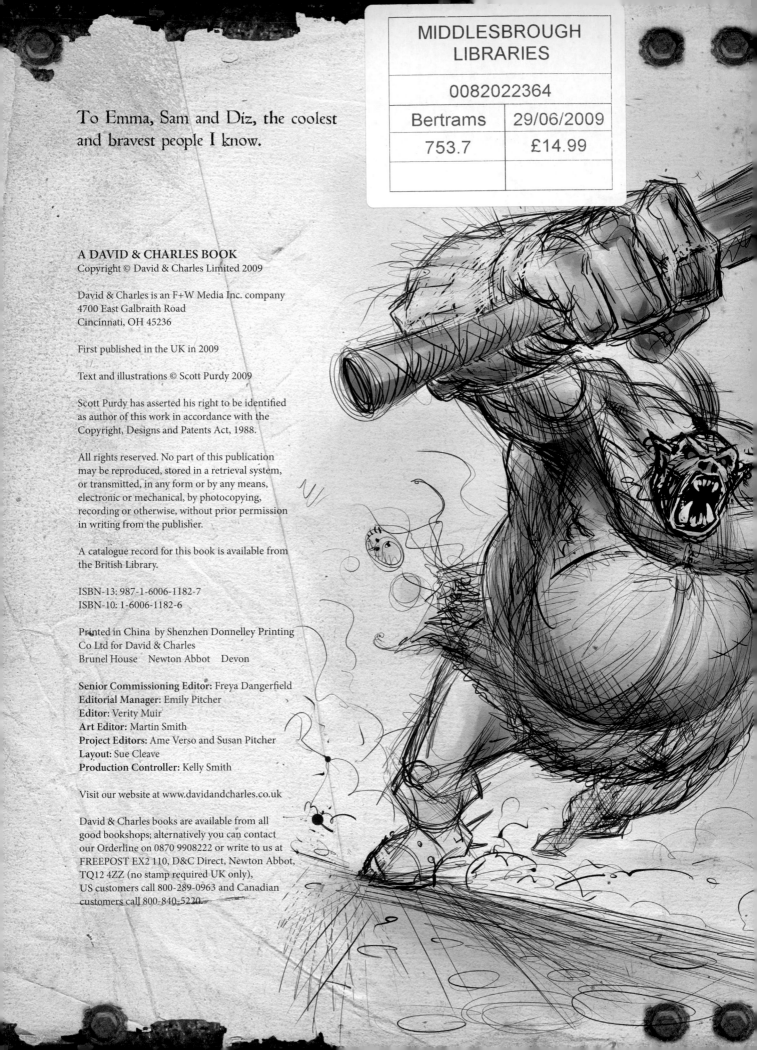

To Emma, Sam and Diz, the coolest
and bravest people I know.

A DAVID & CHARLES BOOK
Copyright © David & Charles Limited 2009

David & Charles is an F+W Media Inc. company
4700 East Galbraith Road
Cincinnati, OH 45236

First published in the UK in 2009

Text and illustrations © Scott Purdy 2009

ISBN-13: 987-1-6006-1182-7
ISBN-10: 1-6006-1182-6

Printed in China by Shenzhen Donnelley Printing
Co Ltd for David & Charles
Brunel House Newton Abbot Devon

Senior Commissioning Editor: Freya Dangerfield
Editorial Manager: Emily Pitcher
Editor: Verity Muir
Art Editor: Martin Smith
Project Editors: Ame Verso and Susan Pitcher
Layout: Sue Cleave
Production Controller: Kelly Smith

Visit our website at www.davidandcharles.co.uk

David & Charles books are available from all
good bookshops; alternatively you can contact
our Orderline on 0870 9908222 or write to us at
FREEPOST EX2 110, D&C Direct, Newton Abbot,
TQ12 4ZZ (no stamp required UK only),
US customers call 800-289-0963 and Canadian
customers call 800-840-5220.

CONTENTS

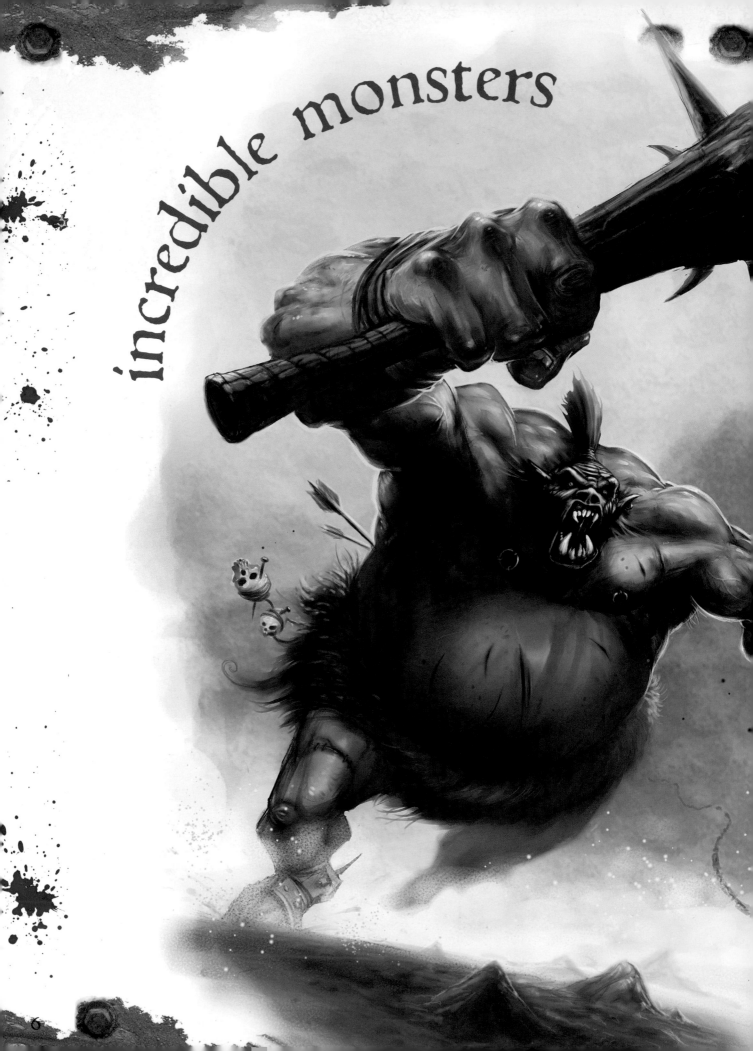

incredible monsters

InTRodUction

T here is little doubt that goblinoids are some of the most
colourful and exciting characters of the fantasy world.
No fantasy story or role-playing game would be complete
without its goblins, hobgoblins, half-orcs, orcs, trolls and
ogres. This book explores the amazing world of these eternally
interesting creatures, giving you an insight into their collective
and individual personalities, and, more importantly, equipping
you with the skills and tools you need to draw and paint your
own remarkable goblinoid characters.

Within these pages you will find guidelines on anatomy,
skin, facial expressions and lighting, and an endless stream
of ideas for character creation. These guidelines are not
intended to be hard-and-fast rules but rather areas for further
exploration. The ideas given are not designed for you to copy
to the letter but are a springboard to help you design your
own characters and worlds, letting your imagination run riot.

For me, fantasy art has always been a fascination. Creating
awe-inspiring worlds, incredible monsters, fantastical creatures,
peculiar people and curious quests feels like it is in my blood.
There is nothing quite like the satisfaction of drawing or
painting a dragon attacking a group of adventurers amongst

ancient ruins, or an armoured orc warrior swinging his massive notched axe, hoping to lop off his assailant's head. It brings me a real sense of gratification, and I am sure you must feel the same or you wouldn't be reading this book.

When creating any fantasy illustration, the first thing is to seek inspiration. Before you put pencil to paper, spend plenty of time looking at the work of other artists in books, magazines, films, TV programmes and video games and, above all, on the Internet. Visit fantasy artists' web pages, gaming forums and role-playing websites – there is an ever-expanding amount of brilliant material out there, ready and waiting to inspire you. Once you have stocked your mind, you will be amazed at what flows from your hand.

My aim for this book is that it brings you enjoyment. I hope that you enjoy the artwork, enjoy the quirky characters, enjoy reading their individual stories, and enjoy learning new ways to bring some of this magic into your own work. If you do at least one of those things, then I've done my job properly!

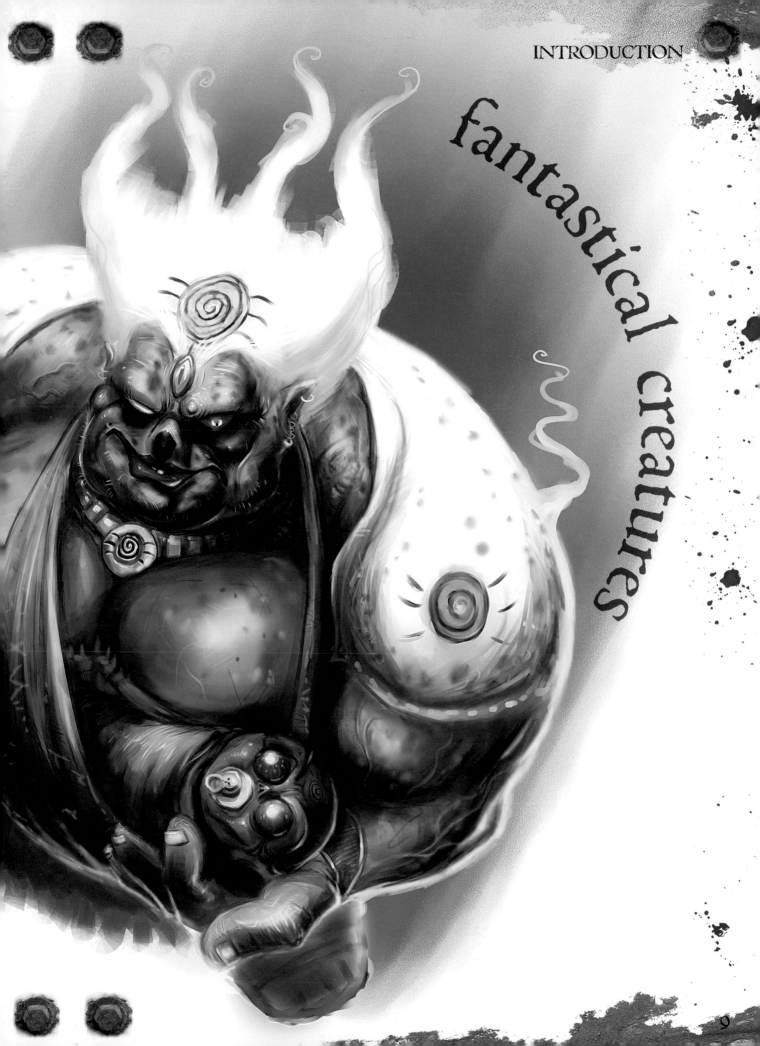

fantastical creatures

HoW to USE THiS book

The information in this book is split into two parts. Part One looks at anatomy, rendering hands and feet, achieving different skin textures, and finally, lighting your characters. Part Two explores each goblinoid race in turn, starting from the smallest, goblins, and increasing in size through hobgoblins, half-orcs, orcs and trolls, and finishing up with the largest, ogres.

Part 1

Part 2

For each race, you will find a general introduction to their physical appearance and usual disposition, and then a fuller exploration of several different 'classes' of characters. By class, I mean what your character does as a 'job', for example warrior, salesman, hunter, torturer and so on.

Class notes

There are a lot of classes in this book from which you can create your own version of, or try out this list for some further ideas. Turn to the Goblinoid Keyword Creator on pages 122–127 for even more.

Archer	Goblin beater	Conscientious objector
Magician	Kidnapper	Nightmare haunter
Fairy hunter	Corpse collector	Royal executioner
Necromancer	Chimney sweep	Spring-heeled jack
Cleaner	Make-up artist	Horse rustler
Potter	Wig maker	Insect master
King	Bug bread maker	Fishmonger
Queen	Pilot	Taxi driver
Blood sniffer	Astronaut	Cheese maker
Cannibal	Toilet cleaner	Scavenger
Cannonball	Bulldozer	Blacksmith
Fire starter	Filth merchant	Laundry worker
Star gazer	Debt collector	Ice warrior
Assassin	Dinosaur rider	Prophet
Henchman	Bat herder	Life drainer
Mad scientist	Dream weaver	Brain surgeon
Soul stealer		
Armourer		
Executioner		
Mendicant		
Eunuch		
Troubadour		
Alchemist		
Cook		
Judge		
Wrecker		

For each class, the character creation then follows a simple structure. On each double-page spread you will find the brief and often amusing story behind the character. This is followed by four simple stages in their development, starting with a very basic plotting out of the key shapes in the image, working through to a more developed sketch, adding the initial washes of colour, to the final finished image. The text accompanying each stage gives pointers on techniques to try in your own work.

MateRIAls + ToOls

I draw and paint digitally, although there is no reason why you can't use traditional media to get similar results. I have tried to keep the practical instruction in this book as generic as possible but inevitably there are processes that can only be replicated using digital tools.

The bonus of working with computers is they are faster, cleaner and a lot less smelly than some of the traditional painting materials you might use. They also make it easier to correct mistakes in your work. As well as being able to 'undo', you also have the magical 'rotate canvas' option, which can help you spot errors, whereas traditional artists have to hold up their work in front of a mirror to do this.

Here are the materials that I use most in my work:

Pencils
To write down and draw out initial ideas, thumbnails and sketches.

Eraser
For correcting mistakes in pencil sketches.

Sketchbook
Essential for scribbling down all of your ideas, methods, colour choices, keywords, etc. You should aim to carry your pencils and sketchbook with you everywhere. You may have a sudden brilliant idea that you can jot down, otherwise you might all too easily forget it.

Personal Computer
You can't draw and paint digitally without this wonderful machine. You need to have a decent amount of memory to work on large paintings. I currently have 3GB of RAM. RAM helps your PC run more smoothly if you are using large brushes.

Monitor, keyboard and mouse

Materials that you need to view your images and use your programs while painting. Having a good-quality monitor is very important. I use a 19in widescreen monitor.

Flatbed scanner

For scanning in your thumbnails and sketches from your sketchbook to transfer into final paintings.

Graphics tablet

Using a mouse to draw and paint can be very difficult. It can be done, but why bother, when using a tablet is quicker and easier, just like using a pencil on a piece of paper. I use a marvellous Wacom Intuos III A5 tablet, and it was well worth the money.

Software

Corel Painter X is the main program I use for my paintings. This is a wonderful piece of software that emulates traditional media. There is an enormous amount of brushes available within the program and it's easy to get lost trying to find the brushes that suit you.

To give you an idea, I use only a handful of brushes, and they are:

- Pencils - Cover Pencil
- Artists' Oils - Tapered Oils Brush
- Oil Pastels - Round Oil Pastel
- Conté - Tapered Conté
- FX - Glow
- Airbrush - Variable Splatter

The other programs I use are Adobe Photoshop 7 and Artrage 2, which I have just started tinkering with. Artrage is a very effective painting program and very cheap, so I would recommend trying it if you can't afford Photoshop or Painter.

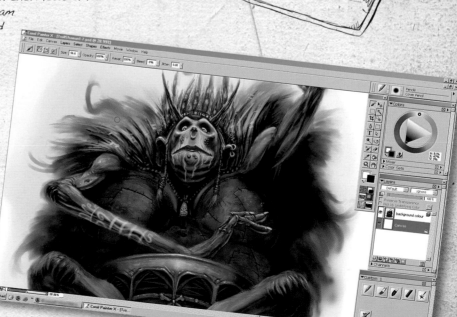

part one » the basics

This section looks at the basics of goblinoid anatomy with key pointers on rendering techniques and advice on lighting, giving you all the foundations you need to create your own fantastic goblinoids.

HuMans vs GobliNoiDs

This is not about the confrontation between man and goblinoid, although admittedly they're always at each other's throats, but rather a look at the most obvious physical differences and similarities between goblinoids and the typical human form.

Humans and goblins - a quick comparison

- A goblin will stand around three or four goblin heads high whereas average human height ranges from six to seven human heads high.
- A goblin's head is overly large for its body, whereas a human head is in proportion relative to its body size.
- Goblin arms are long and spindly and often hang below the knee joints. Human arms are usually well formed and hang beside the thighs, a little way below the waist.
- Humans typically have one head, two eyes, a nose and two ears. They have a body with two arms and legs ending in hands and feet with five fingers or toes. They are generally between six and eight human heads tall (see illustration opposite).
- Goblins share the same bipedal frame and bilateral symmetry as humans (two arms, two legs, two eyes, two ears etc.) but they have very large hands and feet, with only three fingers and a thumb and four toes.

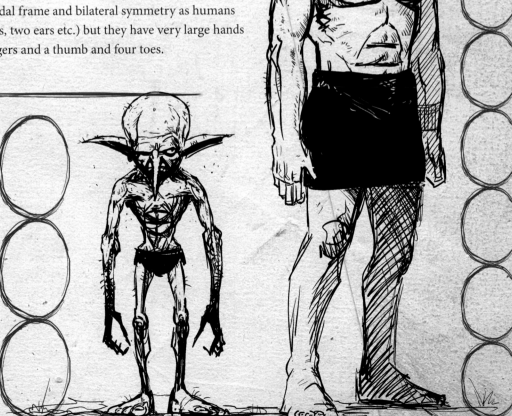

This comparison sketch reveals the most notable physical differences between humans and goblins. Use these proportions as a general guide in your drawings.

Ringing the changes

Looking in more detail, the following differences are also to be noted:

Ears

Goblins have long pointy ears. Human ears are in roughly the same place, but are no way near the same size or shape.

Note how the Goblin ears have ragged edges with chunks missing, usually as a result of fights or accidents, and unsightly sprouting hairs.

Noses

Goblin noses are much longer than a human nose and end in a sharp point. They frequently feature warts, boils and hairs that make them more than a little unappealing.

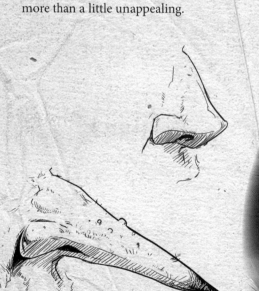

Goblin noses often have noticeable darkening towards the tip, usually red in colour.

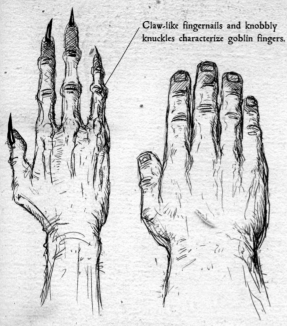

Claw-like fingernails and knobbly knuckles characterize goblin fingers.

Hands

Goblin hands and fingers are much slimmer and longer than those of humans. They often have claws or long dirty nails and their knuckles are very prominent. The biggest difference of all is that they only have three fingers instead of the normal four.

Feet

Goblin feet are gnarly and much narrower than human feet. They have long, dirty claws and knobbly joints.

Goblins have much more slender ankles than humans, but this does not make them graceful in any way.

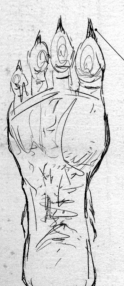

They have sharp, claw-like toenails that are encrusted with filth and slime.

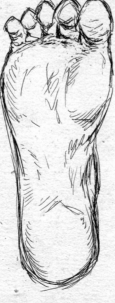

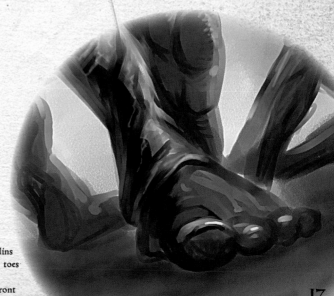

Generally, goblins only have four toes that are spread evenly at the front of the foot.

baSIc AnAtOMy

Building goblinoid characters from shapes

Always plan the pose of your goblinoid characters before jumping straight in to the finished sketch. One way of helping you to do this is to use lots of different shapes to build up the body of your character and give you a solid foundation to work from. Here are a few simple sketches of some shapes that you can use.

Using the shapes shown on the right, it is a simple step to create figures with the correct anatomy and attitude. The basic demonstration below will guide you in this process.

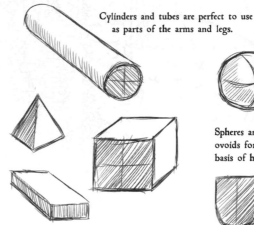

Cylinders and tubes are perfect to use as parts of the arms and legs.

Spheres and ovoids form the basis of heads.

Cubes and pyramid shapes work well for hands and feet.

Goblin

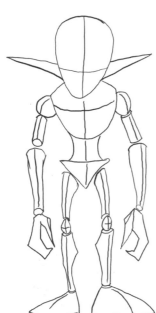

1 Block in the basic shapes using tubes for the arms. Note that if a limb is moving slightly towards the viewer you'll be able to see the flat end of the tube, giving it more of a 3D look. Use a sphere or ovoid shape for the head, and various other shapes for the body.

2 Define the shapes a little more to make them look more like arms, legs, body and head. Separate the fingers into tube shapes. Draw a horizontal line about one-third of the way down the face to mark the level of his eyes. Draw a triangle shape for his nose and a horizontal line for his mouth.

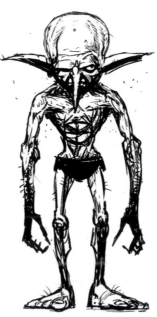

3 Use pencils to add costume elements and additional details, such as these furry shorts and flies buzzing around him to make him appear as if he smells. The facial expression should also begin to become more defined at this stage (see pages 32-33).

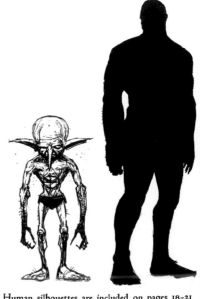

Human silhouettes are included on pages 18-21 to give a scale reference for the six races.

Hobgoblin

Follow the same three basic steps as for the goblin (opposite) but making the character slightly taller with a more elongated head shape. Make different choices with costume and other details, such as this raggedy old cloth as clothing, some wispy loose hair and a couple of ear piercings.

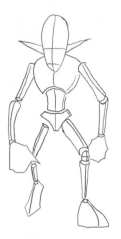

Block in similar body shapes to the Goblin.

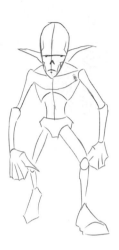

Make sure the head is elongated.

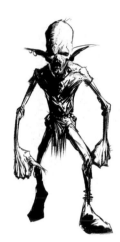

Hobgoblins are slightly taller than goblins, exhibiting a ratio of nearer four heads to their height.

Half-Orc

The same steps apply for this character type too, but notice how the shapes start to become more rounded and chunky. The height ratio is a fraction larger than that of a human and clearly 'beefier'.

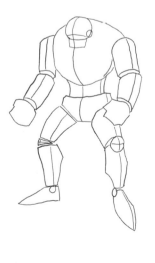

Thick tubes form the basis of the arms and legs, with the head set further down the torso.

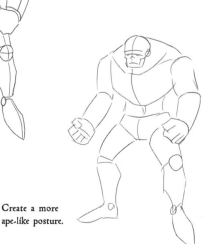

Create a more ape-like posture.

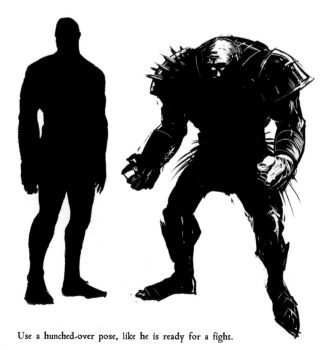

Use a hunched-over pose, like he is ready for a fight.

Orc

Again, build up the character from shapes, creating a figure much bigger in size than a human. Orcs are veritable fighting machines so armour and weapons are crucial. This orc has a giant axe and massive spiked shoulder pads.

Use rounder shapes for the upper body, supported by less robust legs.

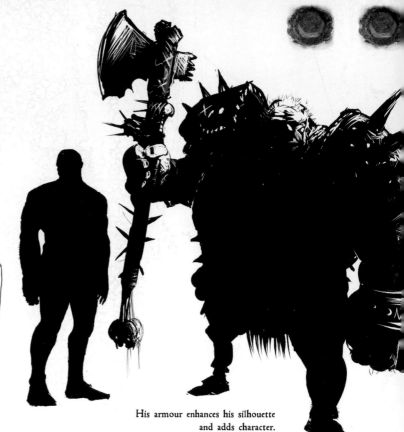

A small head and large, lumbering fists are trademark orc features.

His armour enhances his silhouette and adds character.

Troll

The shapes used for trolls are the same as all the other types but just arranged in a different way. Finish off your troll with a slightly confused look on his face, a bushy mop of hair and long loose hair hanging down from his armpits.

Long tubes make up the arms and legs to construct a creature a great deal bigger than a human.

Extra long arms, large feet and horns are the factors that set a troll apart from the other goblinoid races.

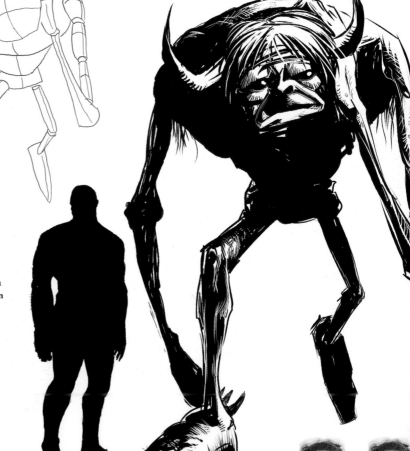

Ogre

The largest of the goblinoids, towering above humans, ogres are made up of more rounded and compressed shapes. When it comes to adding detail, make sure you include the lumpy texture of his skin and some spines projecting from the back and shoulders to add visual interest to the silhouette.

Notice how the head is set even further down the torso, and the massive forearms convey a sense of weight, even in the earliest sketch.

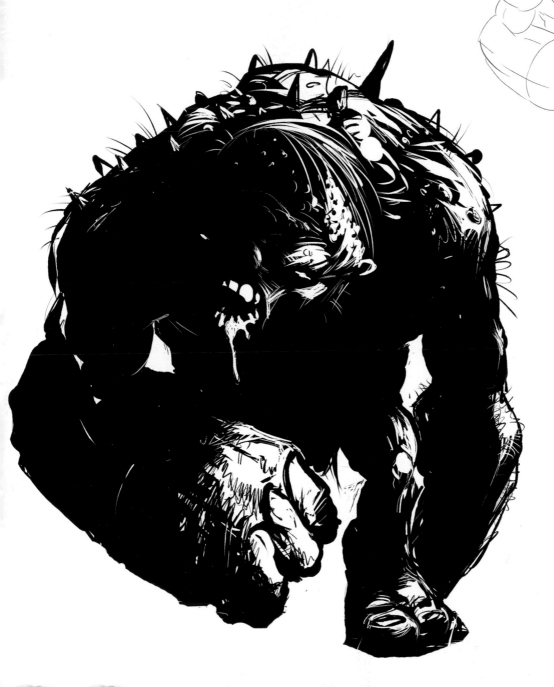

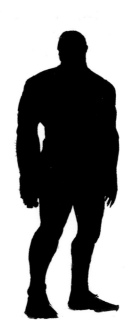

SKELEton

The skeletal frame of your goblinoid is very important. Not only does it give you a gauge of how a creature appears physically but it also implies how it might move. If a goblinoid consisted of only muscle, guts and skin you would have a very squidgy pile on the floor!

Broad thick bones can indicate large, strong muscles, and long thin bones suggest a more wiry musculature. Comparing and observing the differences in the various races' skeletons can be helpful for you when drawing.

It is beyond the scope of this book to reveal in detail how the skeletal frame works and moves. If you wish to explore this further, you can look at anatomy books in your local library. The examples here show an average framework for each of the goblinoid races. The drawings have been kept simple, revealing only the most obvious bones and are not shown to scale – the ogre skeleton would be around four times larger than the goblin.

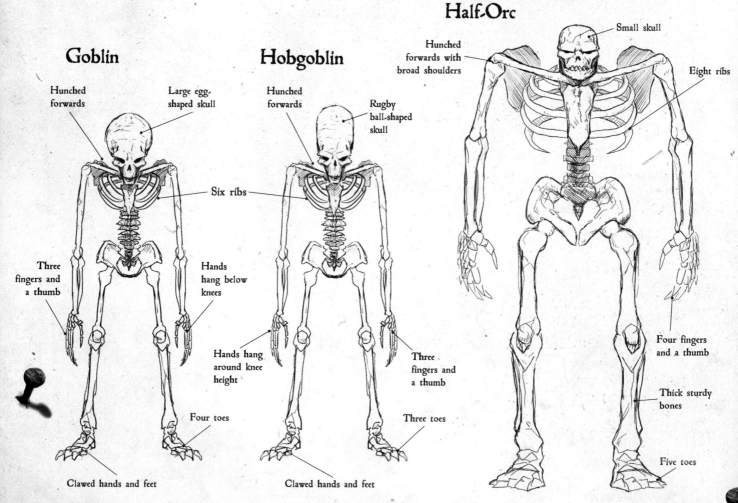

Goblin

- Hunched forwards
- Large egg-shaped skull
- Six ribs
- Three fingers and a thumb
- Hands hang below knees
- Four toes
- Clawed hands and feet

Hobgoblin

- Hunched forwards
- Rugby ball-shaped skull
- Hands hang around knee height
- Three fingers and a thumb
- Three toes
- Clawed hands and feet

Half-Orc

- Small skull
- Hunched forwards with broad shoulders
- Eight ribs
- Four fingers and a thumb
- Thick sturdy bones
- Five toes

Orc

Square skull

Eight ribs

Hunched forwards
with extremely
broad shoulders

Long
forearms

Three fingers
and a thumb

Thick bone structure

Five toes
(with exceptions)

Troll

Hunched forwards
with broad shoulders

Large wide skull
with horns

Eight ribs

Short
thighbones

Long thin
bone structure

Three
fingers and
a thumb

Arms hang down
near ankles

Three or
four toes

Ogre

Large wide oval skull speckled
with small spikes

Hunched forwards with very
broad shoulders

Eight ribs

Massively thick
bone structure

Long arms and
short stocky legs

Three fingers
and a thumb

Two toes

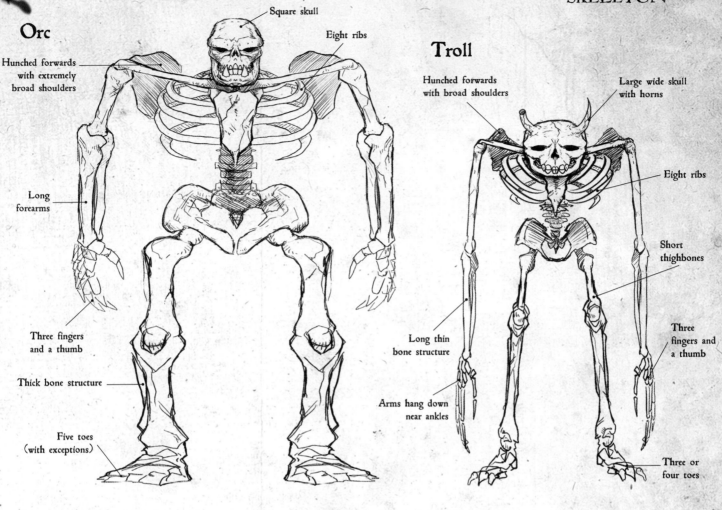

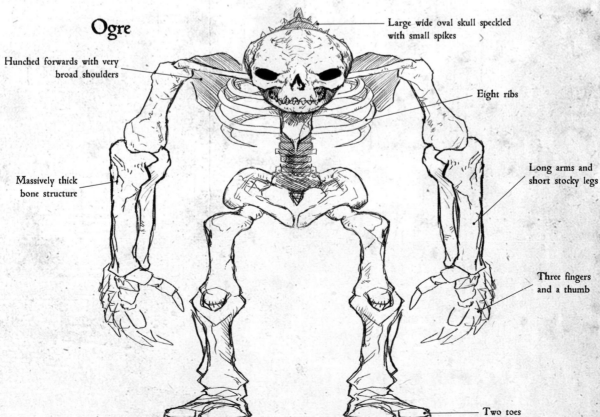

HEaDs + SKulls

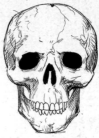

The skull holds the all-important brain of a goblinoid and is the frame that carries one of the most crucial tools for adding character: the face.

Like the skeleton, the shape and size of the skull denotes which race it belongs to. Compare the similarities and differences (profile and front view) of all the goblinoid skulls with the human skull on the right to help you understand and construct the facial framework more easily.

Overlaid in red you can see how the skin and flesh of the goblinoids might cling to these skulls. As a fun exercise, photocopy or trace some of the skulls and then draw over how *you* think the faces should look.

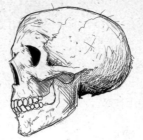

Human skull

Goblin

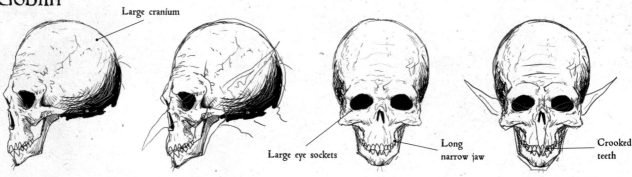

Large cranium

Large eye sockets

Long narrow jaw

Crooked teeth

Hobgoblin

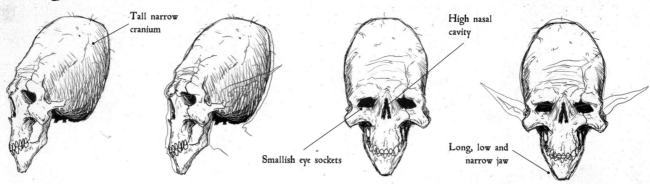

Tall narrow cranium

High nasal cavity

Smallish eye sockets

Long, low and narrow jaw

Half-Orc

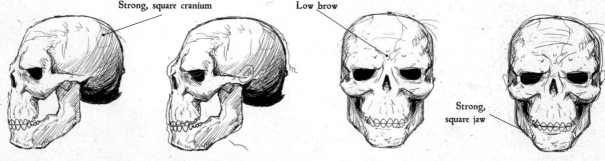

Strong, square cranium

Low brow

Strong, square jaw

Half-Orc skulls are more like human skulls than any of the other goblinoids, due to their half-human heritage.

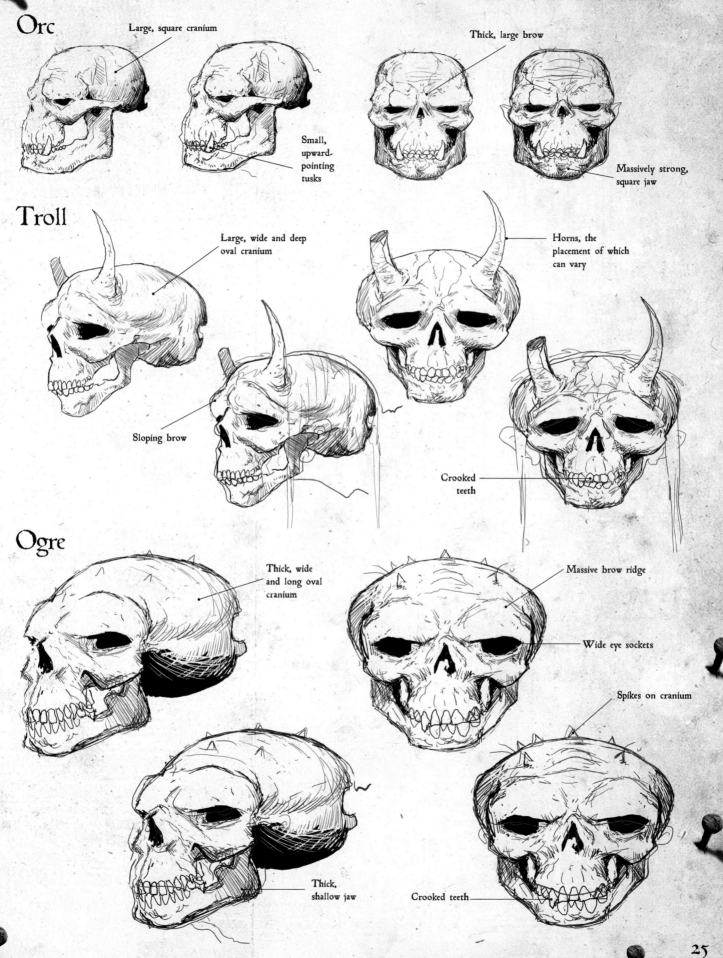

Orc

Large, square cranium

Thick, large brow

Small, upward-pointing tusks

Massively strong, square jaw

Troll

Large, wide and deep oval cranium

Horns, the placement of which can vary

Sloping brow

Crooked teeth

Ogre

Thick, wide and long oval cranium

Massive brow ridge

Wide eye sockets

Spikes on cranium

Thick, shallow jaw

Crooked teeth

HAnDs

There are two distinct shapes of hand that cover all of the goblinoid races: thick strong hands and thin delicate hands. Goblinoid hands differ in size and shape, in the number of digits, in the width and length of the fingers and in the breadth and depth of the palm. As with the other body parts, you can use simple shapes to help draw hands. Use tube shapes to construct the digits and cuboids for the palms. The thickness or thinness of your goblinoids' palms and fingers will depend on the breadth and depth of your shapes.

Thin hands

Goblins, hobgoblins and trolls have thin wiry hands. They're not built for strength and are not heavily muscled, but don't let that fool you – thin hands can still be very strong. The only differences between goblin, hobgoblin and troll hands are the scale and the number of digits. Although on previous pages I've given you an idea of how many fingers they should have, it is up to you how many digits you give your characters.

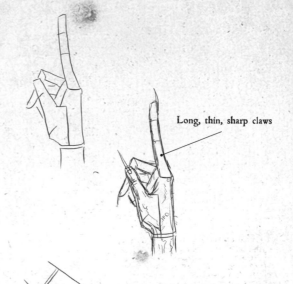

Long, thin, sharp claws

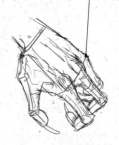

The knuckles and joints are very prominent in thin hands

Simple shapes can help you create complicated hand gestures

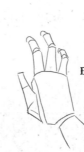

Extra long joints

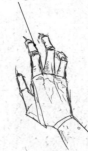

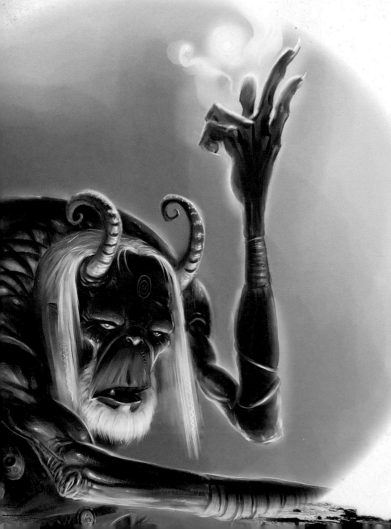

Troll hands are extremely long and thin with knobbly knuckles and joints. Take a look at your own hands, closely examining the folds around the joints and knuckles - really overemphasize these features when drawing troll hands.

Thick hands

Half-orcs, orcs and ogres all have thick, solidly muscled hands. Built for brute strength, smashing, crushing and squeezing, they are true warrior-like hands. But while thin hands can also be strong, thick hands can equally be surprisingly delicate when required.

Orcs hands are for crushing their enemies. Broad fat fingers with a heavily muscled padded palm for gripping and squeezing are in order here. Draw in the chunky shapes then work up the skin and flesh. Examine your own hands to see where all the contours, skin and muscles bunch and fold when you grip something.

Using thicker shapes can help with drawing the hand gestures for half-orcs, orcs and ogres

Thick, fleshy fingers

Wide nails/claws

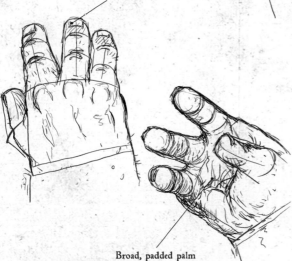

Broad, padded palm

This troll's hands are thicker than the norm. There is no reason why you can't work in a mixture of fat fingers with thin palms or any combination that suits you. Experiment with different sizes and shapes, over and under exaggerating all the elements.

Feet

Goblinoid feet fall into the same two basic categories as hands (see pages 26–27), thick and thin. The more weight a goblinoid has on its body, the more effect it will have on the shape and condition of its feet. A heavy bulk will result in solid, wide, thick-padded, chunky-toed feet. The lighter the bulk, the slimmer and thinner the feet will be. If you draw fewer toes, remember that the weight disperses across the foot and makes the toes spread, so make the toes larger in size or it may look as though the foot cannot hold the weight.

Thin feet

Goblins, hobgoblins and trolls generally have long thin feet and toes to help hold up their wiry frames, but trolls can be the exception here, some of them having large chunky feet. The only real differences between the feet of these races are the scale and the number of toes (see pages 22–23). These shapes give you a framework to draw on.

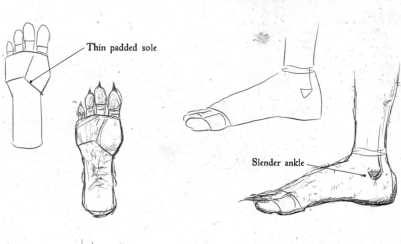

Thin padded sole

Slender ankle

Long toes

Prominent knuckles and joints

Very flexible toes

This troll has a foot with three large toes to support its weight. Notice how the toes spread to help distribute the pressure evenly across the foot when walking or standing.

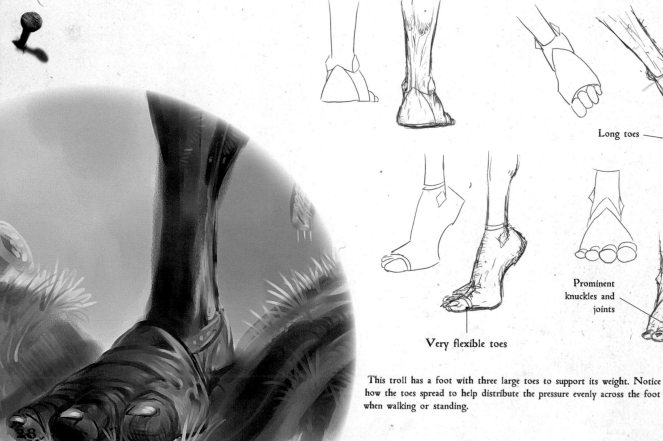

Thick feet

Half-orcs, orcs and ogres have massively thick and bulky feet that are essential to hold up their huge, weighty frames. Trolls can also have thick, chunky feet.

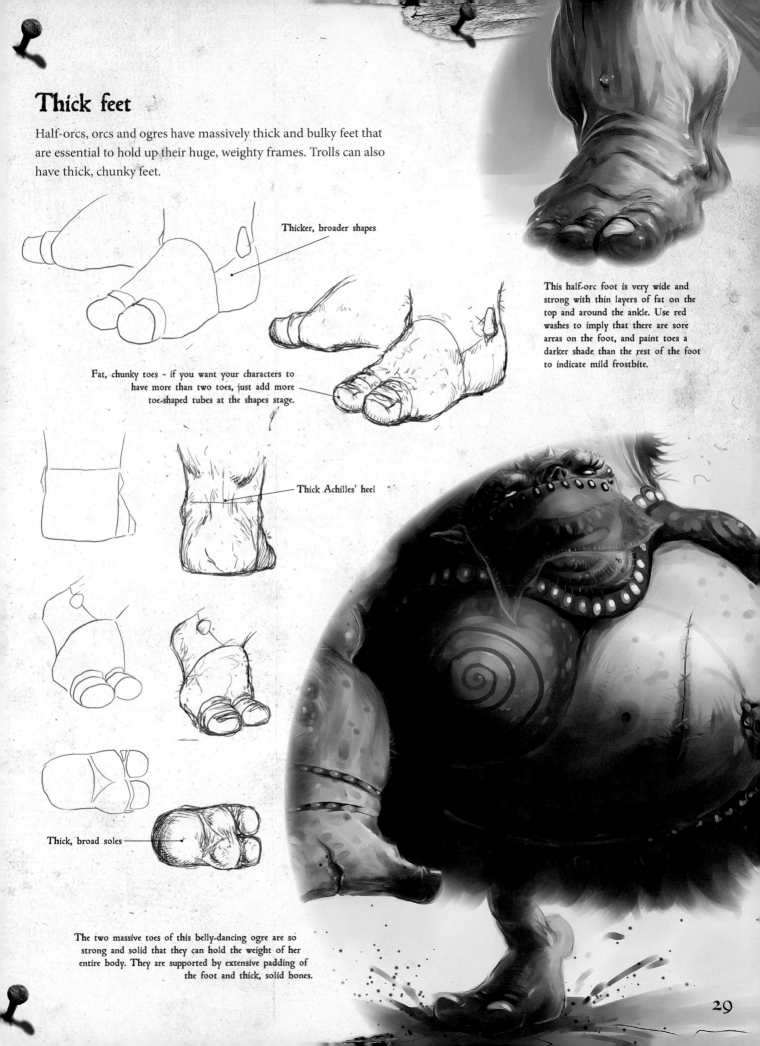

Thicker, broader shapes

Fat, chunky toes - if you want your characters to have more than two toes, just add more toe-shaped tubes at the shapes stage.

Thick Achilles' heel

Thick, broad soles

This half-orc foot is very wide and strong with thin layers of fat on the top and around the ankle. Use red washes to imply that there are sore areas on the foot, and paint toes a darker shade than the rest of the foot to indicate mild frostbite.

The two massive toes of this belly-dancing ogre are so strong and solid that they can hold the weight of her entire body. They are supported by extensive padding of the foot and thick, solid bones.

29

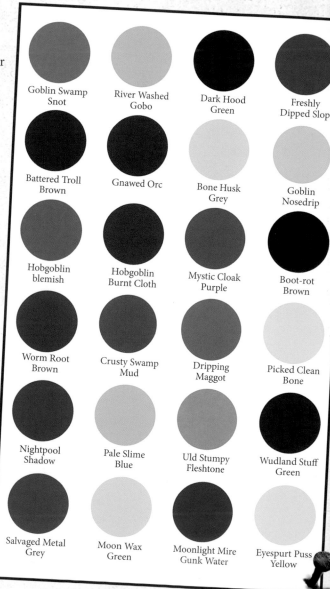

SKIN + HAIR

Goblinoids come in all shades and colours. The characters in this book have been painted with a limited range of earthy colours, with the hobgoblins in shades of violet, but there is no reason why you can't use any colour you like in your own work. The skill of rendering goblinoid skin is not only about colour choice but also in successfully conveying their highly textured nature, which is usually characterized by boils, lesions, warts, gouges, cuts, scars, stitches and sprouting hairs.

Skin colour

The chart on the right shows some of the goblinoid skin colours I use regularly. In general, use a mid-tone colour as an initial wash, then use a darker tone of a similar colour for the shadow and finally a lighter tone for the highlighting. Try any combination of these colours to see the effects you can get.

Hair

To paint hair, first decide on the style. Don't paint in each hair strand, instead treat the hair as one mass and fill in a mid-tone colour. Then decide on the light direction and gently wash in the shadows and highlights. Finally, blend in the tones, gradually reducing the brush size to pick out any fine strands that reflect the light.

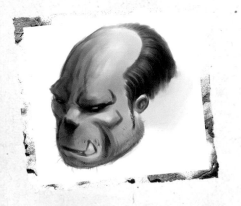

These goblinoids have hairstyles that help to convey their characters: a mad warrior's shock, insanely large white frizz, lank hair, a mohican-style crop and long yellowing locks.

Goblin Swamp Snot	River Washed Gobo	Dark Hood Green	Freshly Dipped Slop
Battered Troll Brown	Gnawed Orc	Bone Husk Grey	Goblin Nosedrip
Hobgoblin blemish	Hobgoblin Burnt Cloth	Mystic Cloak Purple	Boot-rot Brown
Worm Root Brown	Crusty Swamp Mud	Dripping Maggot	Picked Clean Bone
Nightpool Shadow	Pale Slime Blue	Uld Stumpy Fleshtone	Wudland Stuff Green
Salvaged Metal Grey	Moon Wax Green	Moonlight Mire Gunk Water	Eyespurt Puss Yellow

Skin defects

Head of a half-orc

Here is a very basic half-orc head to demonstrate how to add texture and character by applying different flaws.

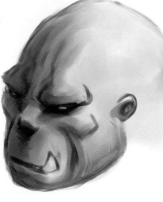

Boils

Paint in some circular shapes in a variety of sizes. When you're happy with the shapes, paint in a deep red directly on top and wash gently around the boils with the same colour to leave a pale reddish shade. Add pinpricks of yellow on the most prominent boils.

Stitches

Draw in the scar following the body contours. Create the stitches or staples in pencil in the same colour. To paint metallic staples, choose a pale grey-blue and paint in the highlights using a brush to blend the colours. Wash in some red then draw in any texture and highlights with a pencil.

Warts

Draw in the warts using a pencil, picking up the darkest colour from around his eyes then gently brush in the shadows. For highlights, pick up the colour from the lightest part of his head. It's worth looking at picture references of warts, as there are lots of different types.

Sores

Use the oil pastel brush to carve and shape the sore, picking up colour from the lightest and darkest parts of the head. Add a red and orange wash then draw in weeping fluid with a very fine-tipped brush. Finally add bright yellow highlights.

Scars

Draw scars in pencil in a dark colour following the body contours. Pick a bright saturated red and gently brush some highlights into the scar to give the effect that the wound is open. Wash over a crimson red around the scar to make it look sore then add some final highlights.

FAciaL ExpREsSiOns

Crucial to conveying the attitude and personality of your goblinoid characters, a wide range of facial expressions need not be difficult to achieve in your paintings. In real life, if a person's facial expression never changed you would need to speak to them to determine how they were feeling. As your viewers can't communicate with your paintings verbally, you need to use clear facial expressions in order to evoke the desired response.

The basics

Looking at these quick examples, it's easy to read the simple lines and shapes to work out the expressions. An upturned arc for the mouth automatically reads as happy in our minds, likewise a down-turned arc reads as sad. The position of the eyebrows also helps in determining the more complex emotions.

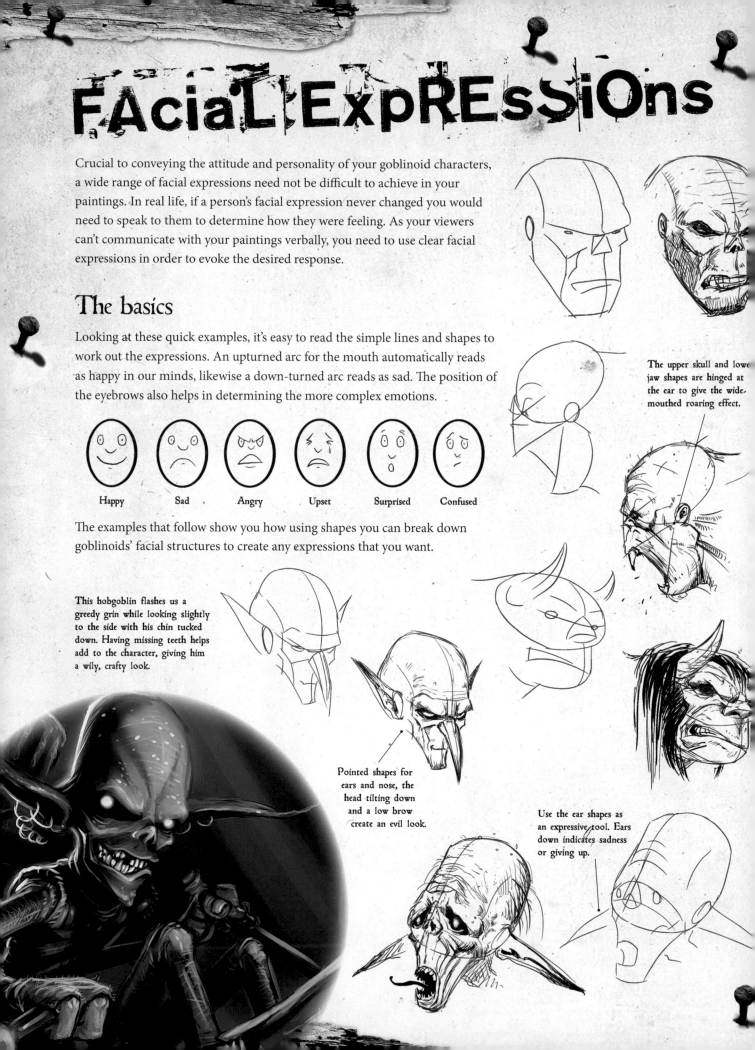

Happy Sad Angry Upset Surprised Confused

The examples that follow show you how using shapes you can break down goblinoids' facial structures to create any expressions that you want.

The upper skull and lower jaw shapes are hinged at the ear to give the wide-mouthed roaring effect.

This hobgoblin flashes us a greedy grin while looking slightly to the side with his chin tucked down. Having missing teeth helps add to the character, giving him a wily, crafty look.

Pointed shapes for ears and nose, the head tilting down and a low brow create an evil look.

Use the ear shapes as an expressive tool. Ears down indicates sadness or giving up.

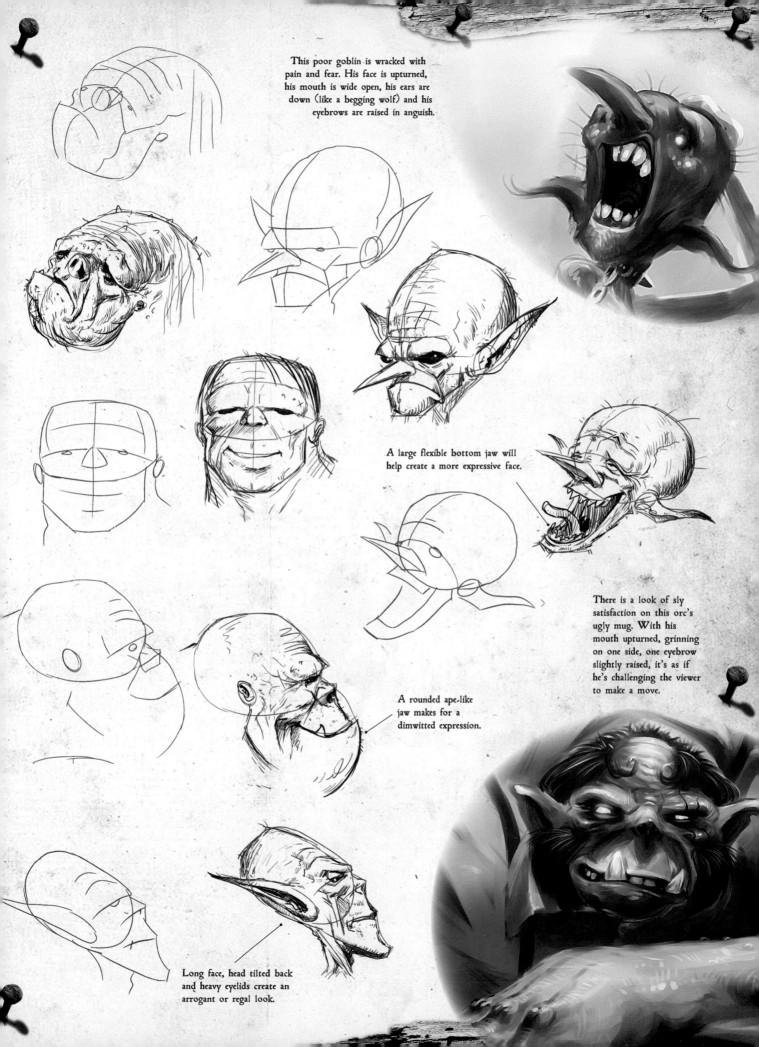

This poor goblin is wracked with pain and fear. His face is upturned, his mouth is wide open, his ears are down (like a begging wolf) and his eyebrows are raised in anguish.

A large flexible bottom jaw will help create a more expressive face.

There is a look of sly satisfaction on this orc's ugly mug. With his mouth upturned, grinning on one side, one eyebrow slightly raised, it's as if he's challenging the viewer to make a move.

A rounded ape-like jaw makes for a dimwitted expression.

Long face, head tilted back and heavy eyelids create an arrogant or regal look.

LighTiNg

Lighting is a marvellous tool to add mood and atmosphere to your fantasy paintings. Take a look at the work of your favourite fantasy artists and study how they use light and colour to bring their images to life. In particular I recommend you look at the art of John Howe, Jon Hodgson and James Ryman. You will see that they are all very different in style and that they all use lighting differently to create their own individual effects.

This section looks at basic lighting directions and colour, and the atmospheric effect these have on an image. In addition, I tend to use a lot of rim light in my work, which helps to separate the figure from the background, foreground or other elements, by employing a line of light around the figure or object. Rim light is particularly useful for night scenes where you want to create a distinct line to bring out the shapes of your characters.

Lighting simple shapes

Here are some simple shapes stacked together with different lighting conditions. Notice that where the light hits directly on the shapes it makes those points the brightest areas, and that the shadows are cast away from the light source.

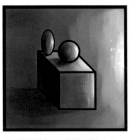

Lit from the right hand side

Lit from above

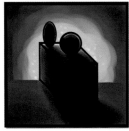

Lit from behind

Lit from below

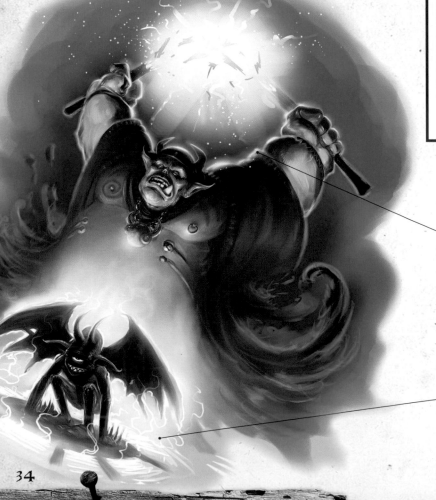

Once you become comfortable with simple lighting, you can begin to play with multiple light sources and rim light for more sophisticated effects. The lighting from the explosion of the broken staff reflects off his helmet, shoulders and arms. The source of this light is slightly behind him so the light only hits the edges rather than washing all over him, which also helps to lift him off the background.

Notice how the light emanating from the demon is very hazy and washes out everything behind it but how it also lights the orc's body and face, which throws up interesting shadows.

Lighting a character

The same principles apply when lighting a character. A goblin's face has been used as the example.

This goblin has a particularly nasty look on his face, so experiment with different lighting directions to help accentuate the evil emanating from him. He will always look evil, but some of the lighting schemes make him look nastier than others. Which do you think works best?

Coloured light

Once you have determined which lighting direction will bring out the best in your image, wash over it with a flat saturated colour. The use of colour in your lighting scheme can help to create a completely different feel and can also give you ideas for settings. For example, the last panel in this sequence reminds me of a floating head in a weird-and-wonderful science lab and the drawing could now be developed and expanded to suggest this as the location of the image.

Lit from the right-hand side

Lit from above

Lit from behind

Lit from below

part two» the goblinoids

The Goblin World

Birthplace of Noobel Pidgeonfoot, the goblin rocketeer, and where he crashed his first 'rokit'.

The hobgoblin, Grimtooth 'Smokey' Sharpshoot enforces the law in The Westunlands with his feared Kaboomerstick weapon.

The persecuted ogre Orgrod Darkblade and his magical sword are inching their way through these tunnels to take revenge on the tribe at Ogrock.

Shenshik the Lonely, a peaceable half-orc, and his faithful companion, Meeshu, protect the forest and its creatures from all who would harm them.

MARABELLE

THE WESTUNLANDS

Freedom Bridge

Under

CARAMOR FOREST

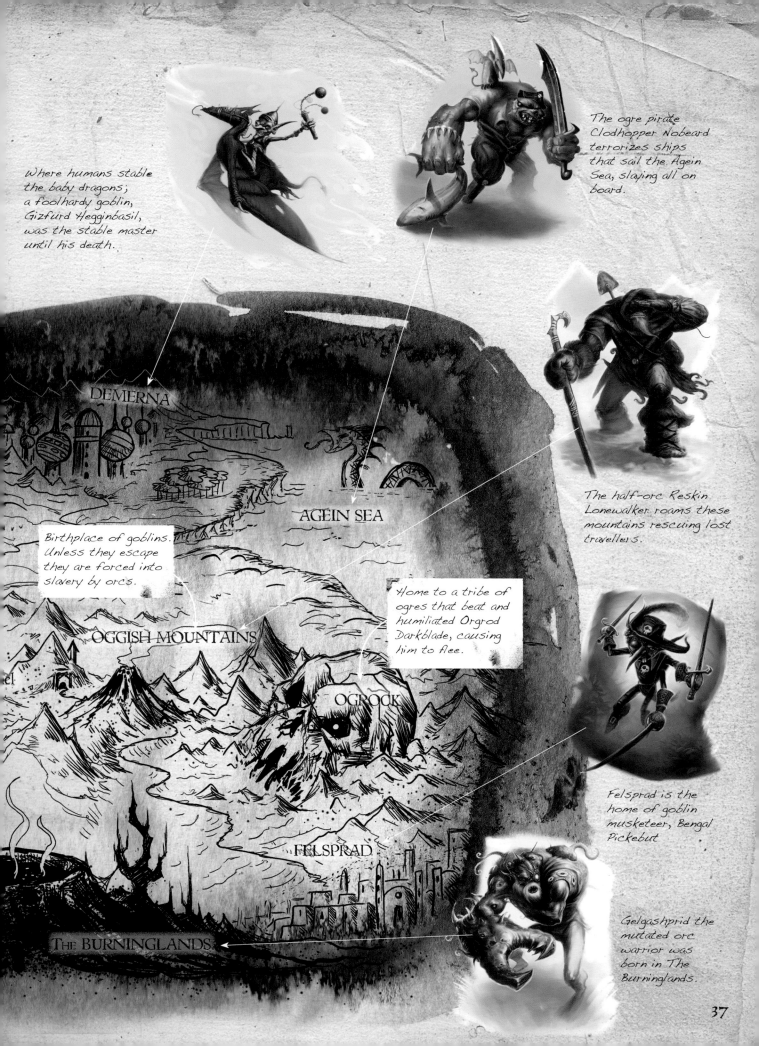

Where humans stable the baby dragons; a foolhardy goblin, Gizfurd Hegginbasil, was the stable master until his death.

The ogre pirate Clodhopper Nobeard terrorizes ships that sail the Agein Sea, slaying all on board.

Birthplace of goblins. Unless they escape they are forced into slavery by orcs.

The half-orc Reskin Lonewalker roams these mountains rescuing lost travellers.

Home to a tribe of ogres that beat and humiliated Orgrod Darkblade, causing him to flee.

Felsprad is the home of goblin musketeer, Bengal Pickebut

Gelgashprid the mutated orc warrior was born in The Burninglands.

DEMERNA

AGEIN SEA

OGGISH MOUNTAINS

OGROCK

FELSPRAD

THE BURNINGLANDS

37

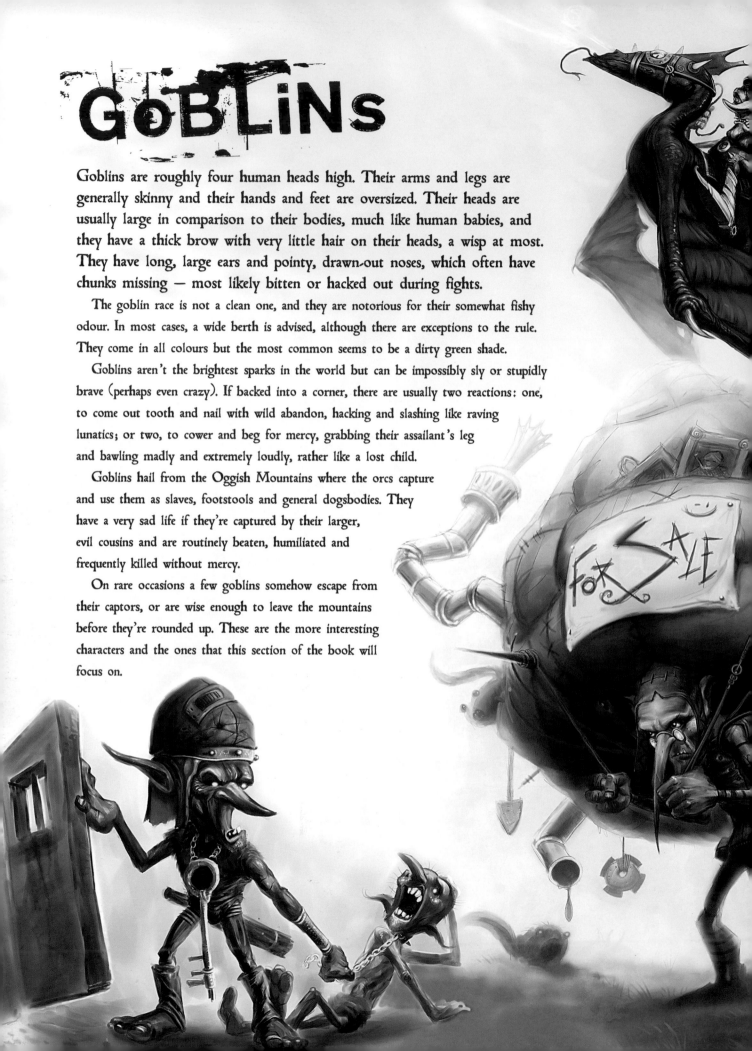

GOBLINS

Goblins are roughly four human heads high. Their arms and legs are generally skinny and their hands and feet are oversized. Their heads are usually large in comparison to their bodies, much like human babies, and they have a thick brow with very little hair on their heads, a wisp at most. They have long, large ears and pointy, drawn-out noses, which often have chunks missing — most likely bitten or hacked out during fights.

The goblin race is not a clean one, and they are notorious for their somewhat fishy odour. In most cases, a wide berth is advised, although there are exceptions to the rule. They come in all colours but the most common seems to be a dirty green shade.

Goblins aren't the brightest sparks in the world but can be impossibly sly or stupidly brave (perhaps even crazy). If backed into a corner, there are usually two reactions: one, to come out tooth and nail with wild abandon, hacking and slashing like raving lunatics; or two, to cower and beg for mercy, grabbing their assailant's leg and bawling madly and extremely loudly, rather like a lost child.

Goblins hail from the Oggish Mountains where the orcs capture and use them as slaves, footstools and general dogsbodies. They have a very sad life if they're captured by their larger, evil cousins and are routinely beaten, humiliated and frequently killed without mercy.

On rare occasions a few goblins somehow escape from their captors, or are wise enough to leave the mountains before they're rounded up. These are the more interesting characters and the ones that this section of the book will focus on.

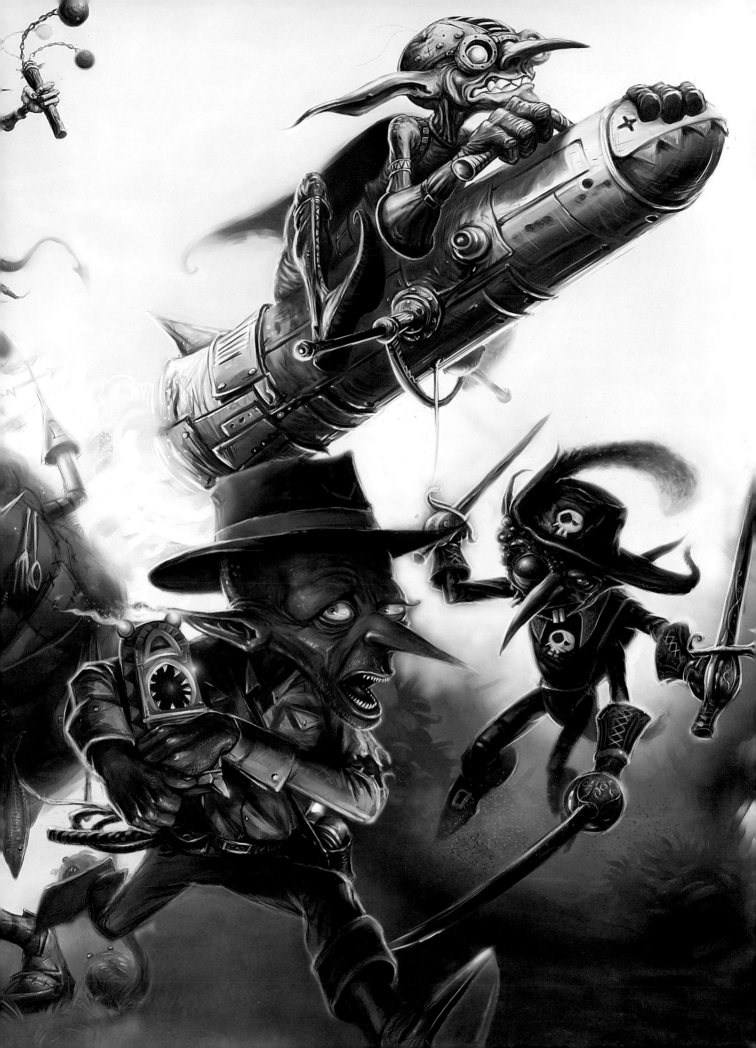

prison guard

Skellington Kee

Skellington is charged with keeping all the prisoners in their cells and considering he's a goblin and prone to poking his prisoners with nasty implements, his detainees are usually very quiet and obedient.

Originally a prisoner in the tower himself on a drunk and disorderly charge, the guards noticed that he was very interested in how they ran the operation. Initially they thought he was planning to escape but as his sentence was only for a week, they dismissed this idea as it came to a close.

After he was released he kept returning to the tower, making begging noises with grunts and groans and waving his gangly arms about – being a mute it's hard for him to communicate. Eventually, after hours of animated charades, they realized that he wanted to work in the tower as a prison guard.

As it's not really a job that requires a huge amount of skill, they decided to take him under their wing and show him the ropes. He proved his worth many times over by covering for the guards when they wanted to have a sleep or a drink or a day off with pay... essentially he is now their 'happy lackey'.

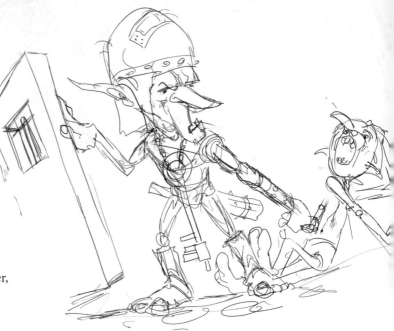

2 As you develop the sketch, give Skelli a grumpy expression, due to the fact that his prisoner is being more than a little awkward for him. Also give him a helmet and a club slung around his waist which he could use if the prisoner continues to resist.

Use the initial wash to determine the lighting scheme, carefully selecting the surfaces that will catch the light and those that will be left in shadow.

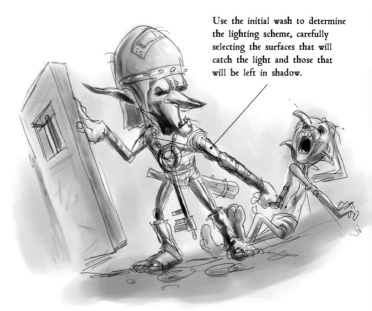

1 As he's a prison guard it makes sense to show Skellington brutally dragging a prisoner into his cell. You only need to hint at the cell so just sketch in the door. Give him a massive key that he hangs on his chest to make himself feel important.

3 Decide which direction the light will come from (here it is right to left), then begin to wash in the tones with a reddish colour to reveal where the shadows and highlights would fall.

Gently wash over Skelli's face using a yellow-green then change to a brown-red for the shadows. Blend the colour using an oil pastel brush and add the highlights with a pencil.

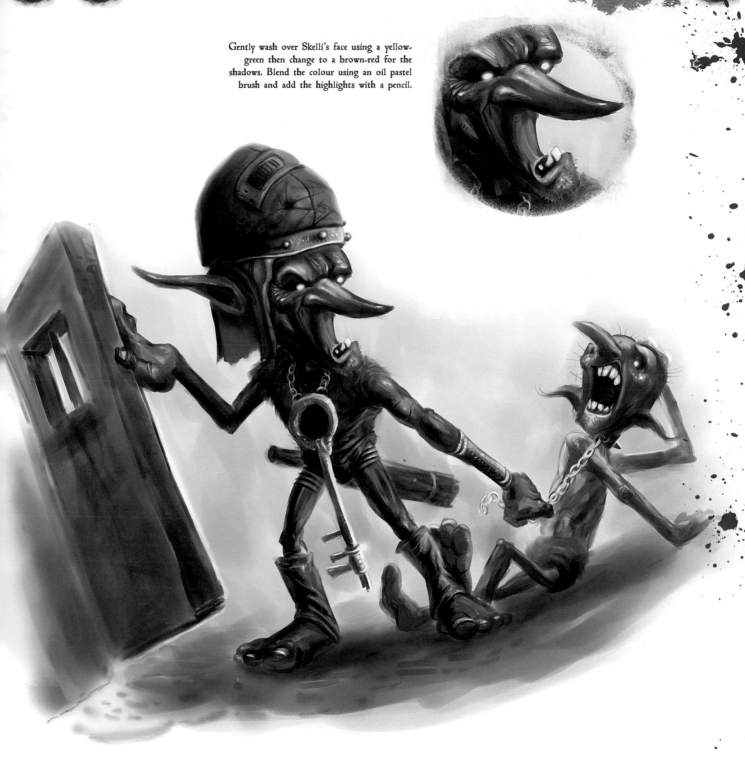

4 With small and detailed brush marks, paint in the colour on the prisoner's head, giving the rest of his body less detail using larger brush marks. Give Skelli a green flesh tone and wash over with light reddish and yellowish browns (taking note of where the light is coming from) to suggest his leather helmet and outfit. Give the helmet a few dents and scratches using a pencil and use opaque pinpoints of paint on the bolts and the rim to make them look metallic. Finally, redden his nose and add some loose texture to the door.

travelling salesman

Mr Pickles

Mr Pickles has been buying and selling his wares for as long as any living person can remember. People often wonder how such an old and skinny goblin can manage to carry such an enormous load and this will forever remain an enigma. He collects odds and ends from all over the land, packing them into his massive load, crawling underneath and groaning loudly as he lifts with his skinny legs.

He's not the happiest of goblins and has a foul temper, as you'd expect from someone who carries such a weight around. Most merchants avoid him whenever possible, knowing that he has a fixed price in mind for buying low and selling high.

To ward off any threat of robbers (or picky merchants), Mr Pickles has trained and bred a group of unique small furry creatures called gambogles. These critters attack ferociously on Mr Pickles' command, grabbing their prey below the waist and never letting go. Legendary tales of the gambogles protecting Mr Pickles have spread far and wide, so it is a rare occurrence indeed for him to be threatened.

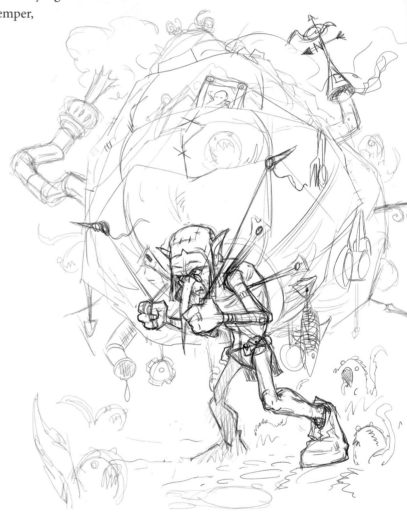

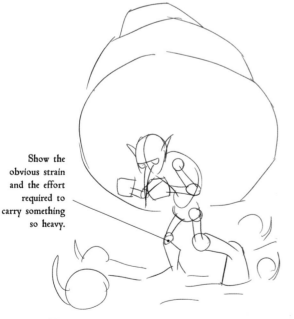

Show the obvious strain and the effort required to carry something so heavy.

1 Mr Pickles doesn't have typical goblin proportions; he's more like a thin old human, so make sure you get that as correct as possible from the beginning. Draw him hunched over under the weight of his load, with just a quick scribble to indicate the gambogles.

2 Flesh out the basic sketch by creating more shapes in the load with lines and bulges. Add lots of knick-knacks, such as pipes, paintings, fish, pots and pans to show the kind of rubbish (and occasional gems) that he sells. Add some straps around his arms to reveal how he carries the load and enhance the sense of strain by giving him clenched fists.

3 Begin washing over with light grey and greens. To suggest the height of the towering bundle, simply reduce the intensity and saturation of colour towards the top of the image – the parts furthest from the viewer.

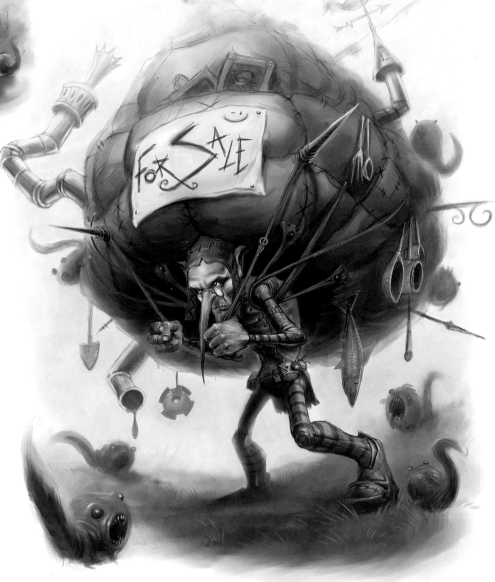

Practise pulling faces in a mirror to help with your characters' facial expressions. To redden the nose use an oil pastel brush. Wash over lightly with red then highlight with yellow. You can use this highlighting on the rest of the character's face too.

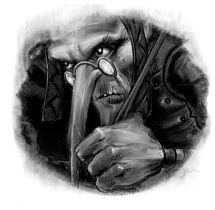

4 Here you can see how the fading out of the load helps to focus the eye on the goblin. Add a 'For Sale' sign to make it completely clear that he is selling his wares. His far leg is not as detailed as the closer leg and is contained mostly in shadow with a little lighting to suggest form. Compare this to his closer leg where there are more details. Wash over the gambogles using a variety of greys/greens and a warm brown for their shading before highlighting their fur, teeth and eyes.

musketeer

Bengal Picklebut

Bengal escaped his wicked parents as a very young goblin child, using his quick wits and fast reflexes. He ran long and far to a wasteland, The Burninglands, knowing nobody would dare follow him across those borders. He lived off of the cursed red lands, eating the twisted plants, hunting the mutated creatures for food and drinking the vile, poisoned water to slake his thirst.

After months of living like a wild animal, he realized that his body was changing – his face seemed to be melting and a stump of a small arm started to grow from his left shoulder. Fearing this land might mutate him further, he fled to the human settlement of Felsprad.

The Felspradian healers, having seen these mutations many times before, explained to Bengal that there was no cure. They said he should embrace his mutation, take advantage of this wonderful new appendage and begin a new life. They trained him in the art of combat, at which he excelled, and the very first goblin musketeer was born.

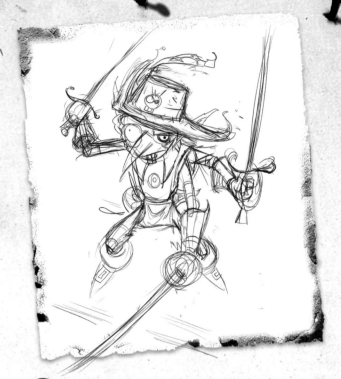

2 Using the initial shapes as a guide, refine the look of Bengal, giving him his foils and characteristic musketeer clothing. By adding just a few details and blocky shadows the image instantly has more movement – he is raised from the ground and leaning forwards as if charging or lurching towards the viewer.

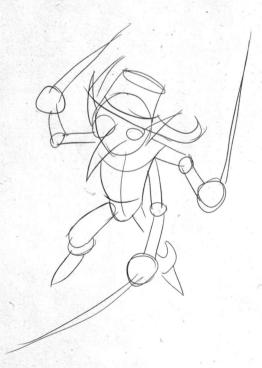

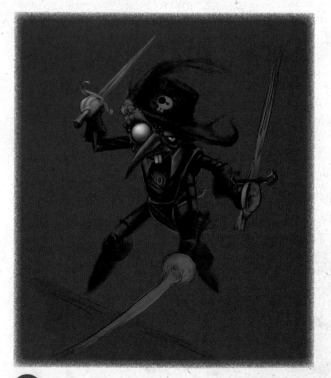

1 From the outset, choose a pose and angle of view that will make his third arm clearly visible and allow the viewer to see his facial mutations – specifically that one eye is larger than the other.

3 Bengal needs to be set in a dirty green environment so use this colour as the basis for the background. Then lay some flat colours on to him and start blending in the edges and adding the initial highlights.

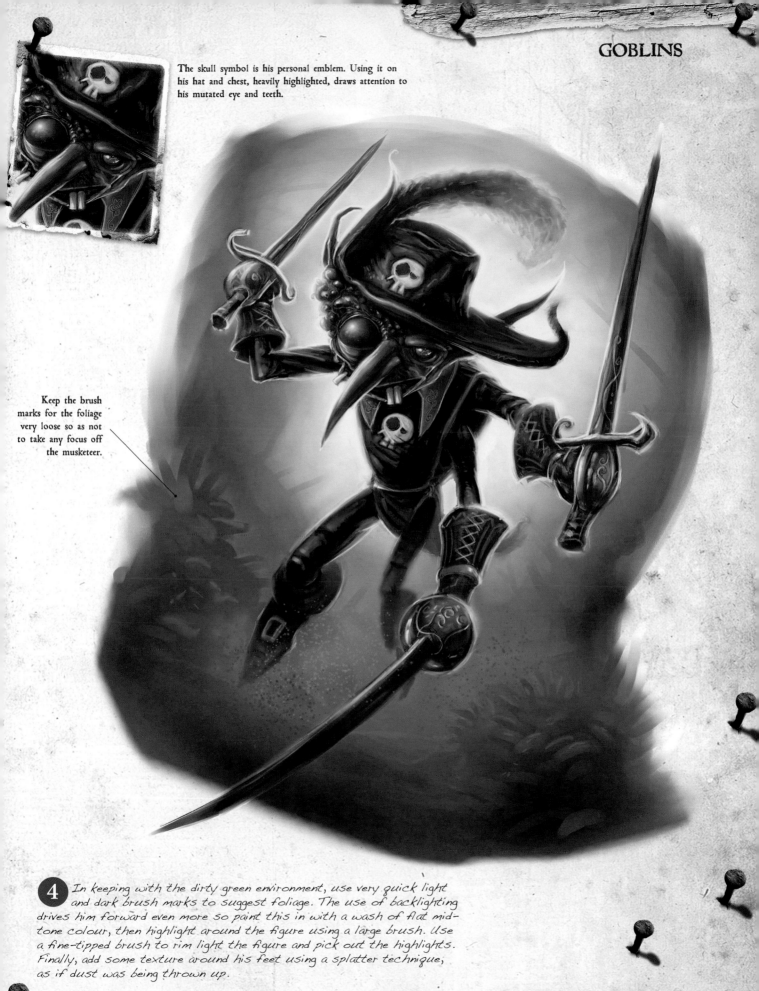

The skull symbol is his personal emblem. Using it on his hat and chest, heavily highlighted, draws attention to his mutated eye and teeth.

Keep the brush marks for the foliage very loose so as not to take any focus off the musketeer.

4 In keeping with the dirty green environment, use very quick light and dark brush marks to suggest foliage. The use of backlighting drives him forward even more so paint this in with a wash of flat mid-tone colour, then highlight around the figure using a large brush. Use a fine-tipped brush to rim light the figure and pick out the highlights. Finally, add some texture around his feet using a splatter technique, as if dust was being thrown up.

treasure hunter

Nisky 'Bones' Finchleskip

For a goblin, Nisky is extremely hardy, but just as foolish as any other. He is probably one of the stupidest but bravest goblins in the land, more often than not getting shot in the bottom by tribal darts, whacked over the head with saucepans, getting caught up in ancient mangling traps and being shot at by his wife (luckily she's a bad shot). But despite all this, he has an amazing amount of good luck. Every time he is caught in a scrape he somehow manages to escape with only minor scratches and bruises. Some wonder whether he picked up a magical item on his travels that saves his skin at the last second. Others believe that he is blessed by the gods, while the majority think he's just an idiot.

He has an extremely powerful sense of smell that helps him hunt down the treasures that he finds. He has been from one end of the world to the other, hunting – or rather 'robbing' – ancient tombs and ruins. He is now renowned for his exploits and collectors flock to him to persuade him to hunt down and reclaim for them. He loves the adventure, discovering new countries and long lost tribes, but most of all he loves the 'shinies' (treasure) that he finds.

2 Like the famous scene from 'Indiana Jones and the Raiders of the Lost Ark', sketch in a massive round rock rolling towards him while he's looking over his shoulder, desperately trying to escape with a gambogle statuette. Give him similar clothes to Jones, including a whip, fedora hat and satchel.

3 Wash in some brown tones for the background and hint at the round rock using a large brush. Paint in his hat, green skin and other clothing and the statuette under his arm.

Create a sense of perspective by drawing the front foot slightly larger than the one behind.

1 The idea for Nisky came from the wonderful character of Indiana Jones. Finding inspiration in movies, video games and books is a great way to start your creations. With the initial shapes, show him holding stolen treasure, running away from something.

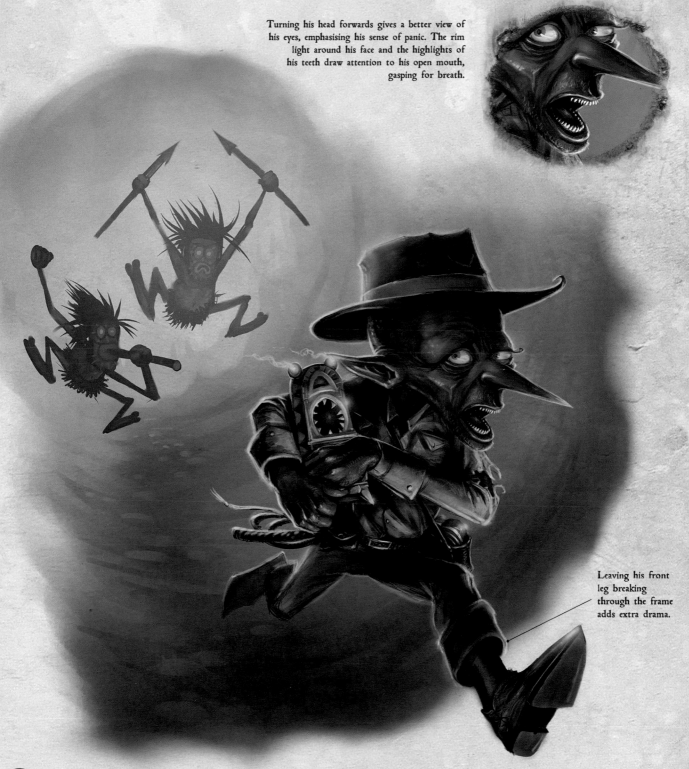

Turning his head forwards gives a better view of his eyes, emphasising his sense of panic. The rim light around his face and the highlights of his teeth draw attention to his open mouth, gasping for breath.

Leaving his front leg breaking through the frame adds extra drama.

4 The final image has changed quite a lot from the previous stage. If you aren't happy with the rock (as I wasn't), completely paint over it with stylized angry tribesmen instead. Turn his head forwards and paint his eyes looking towards the tribesmen as he's running away. Add a glowing trail to the statuette's eyes to give it a magical element, and add some glow to the stones in his satchel to make them seem precious too. Erase some of the grey background to leave a vignette effect. Finally, add a yellowish rim light to his right side, and grey light to his rear to really help him stand out against the background.

rocketeer

Noobel Pidgeonfoot

Noobel grew up in the city of Marabelle. There he learned the relatively new art of 'mekaniks' and engineering. As a student, he would often push his tutors for their knowledge and theories on the possibility of creating flying machines but to his dismay they found this an absurd idea. 'Only magic can make a goblin fly,' they scoffed, 'mekaniks will never do it!'

To prove his tutors wrong, Noobel announced his departure from his official studies to become the first goblin to fly without the aid of magic. Within months he had his first 'test rokit' ready for launch. It was a dismal failure, crashing into the outskirts of the city and causing damage worth hundreds of gold coins. Luckily nobody was hurt but Noobel was exiled from the city while they raided his fortune to pay for the damage.

Two months later, a bright light was spotted in the sky above the city. The inhabitants rushed out into the streets. The light moved ever closer to the city and finally, with squinted eyes, the people could see Noobel sitting upon a massive cylindrical metal object, waving down to them. His tutors, on their knees, could not believe their eyes, but suffice to say that Rokit Engineering is now a new science being taught at the university.

1 *The most important aspect of the initial sketch is the angle of view. In order to give Noobel the appearance of flying, the viewer needs to be looking up at him. Use the basic planes of the rocket to create the composition. Angling the elements in this way instantly suggests upward movement and places the viewer below the action. Give Noobel a forward-leaning stance to further emphasize the rocket's thrust.*

2 *Add the primary details to Noobel, including his flying goggles and helmet, and give the rocket some pedals and a control for him to grip on to tightly. As you can't see his eyes through his goggles, his facial expression is all the more important, so exaggerate his mouth and teeth to capture his exhilaration and fear. Sketch in his hair, ears and cloak flowing backwards in the wind to increase the sense of movement.*

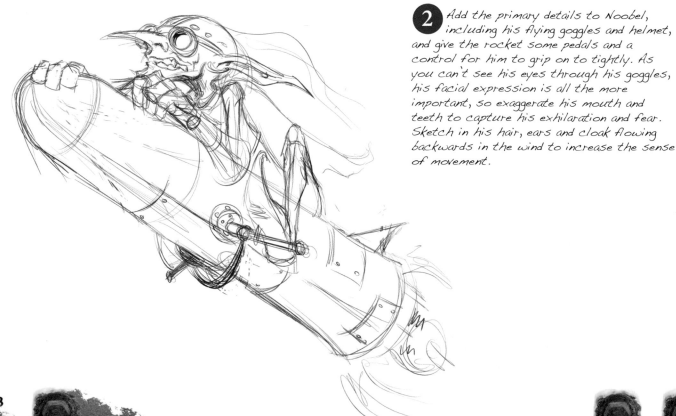

3 *Wash in the basic flat colours, using shades of green and brown for Noobel and metallic greys for the rocket. Keep the background a neutral shade so that the viewer's eye does not wander from the focal point. Use simple shapes in darker washes to suggest distant hills. Begin to suggest the blast of the rocket with bright yellow, and create a reflection of the blue sky above in Noobel's goggles.*

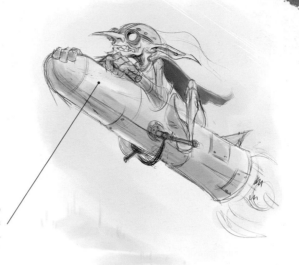

Use the initial wash of colour to help describe the shape of the object with highlights and core shadows.

4 *Continue to add colour and detail until you are satisfied with the image. The rocket needs plenty of details to make it visually interesting. Refine every part of the image as you go and concentrate your attention on the lighting. The bright rocket blast throws reflected light up on to the rocket and Noobel, so paint this in with a small, soft brush. Keep certain elements, such as the cloak, deliberately blurred and lacking in detail to suggest movement and distance from the viewer.*

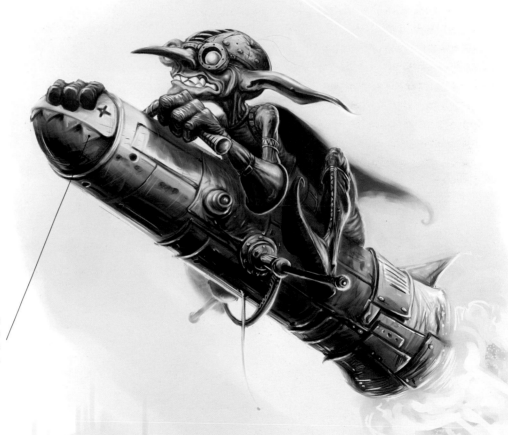

Try out features that mirror those of the rocketeer. Here, the rocket's sharp teeth create a link with Noobel's own expression.

The glare of the rocket blast causes light to be reflected on to the rocket and the rocketeer. The more reflective the surface, the stronger and brighter the contrast between light and dark should be.

dragon rider

Gizfurd Hegginbasil

Gizfurd was recently assigned to the post of stable master to the newly hatched dragons of Demerna. After showing such an affinity for the beasts, and clearly having won their trust, his human masters decided to reward his work by giving him a test run at dragon riding.

Slightly insane by nature and cheered on by this news, Gizfurd jumped at the chance with giddy excitement. Alas, overly confident on his first public ride, he managed to bash himself on the head while swinging his weapon around, and promptly plummeted to his death.

1 Draw out the basic shapes. You can control the composition by having the wings of the dragon flapping downwards. Ifa you draw them upwards instead, they will obscure Gizfurd, which will dramatically change the focus and impact of the image. Choose an angle of view that places the viewer below the action, making it appear that we are looking up at them in the air.

2 Gizfurd's expression needs to be crooked and mad-looking, so sketch this with as much detail as you can to ensure that once you start laying down the colour you don't lose the appeal of that face. Draw in some basic head armour for the dragon, following the contours laid down in the first stage, and draw in some wispy puffs of smoke from his nostrils, keeping the pencil marks very light.

3 Wash in a very pale blue/grey for the background and paint in some nicely saturated green for Gizfurd's skin. In order to enhance the perspective, deliberately keep some parts of the image lower in detail than others. Elements that are further away from the viewer should be painted not only looser, using a large soft brush, but also less saturated to suggest distance.

Notice how the paler areas create depth in the image and increase the focus on the more detailed areas.

Three different levels of saturation make it clear to judge which of the balls on the weapon is closest to the viewer and which is furthest away.

4 In the final stage, paint with stronger saturated colours and add more shadows and highlights to give the character more texture and greater depth. Use a very small, fine-tipped brush to add the slightly demonic glint in Gizfurd's eyes. Finally, add some cloud-like swirls in the background with a soft, fat brush to enhance the impression of moving through the sky.

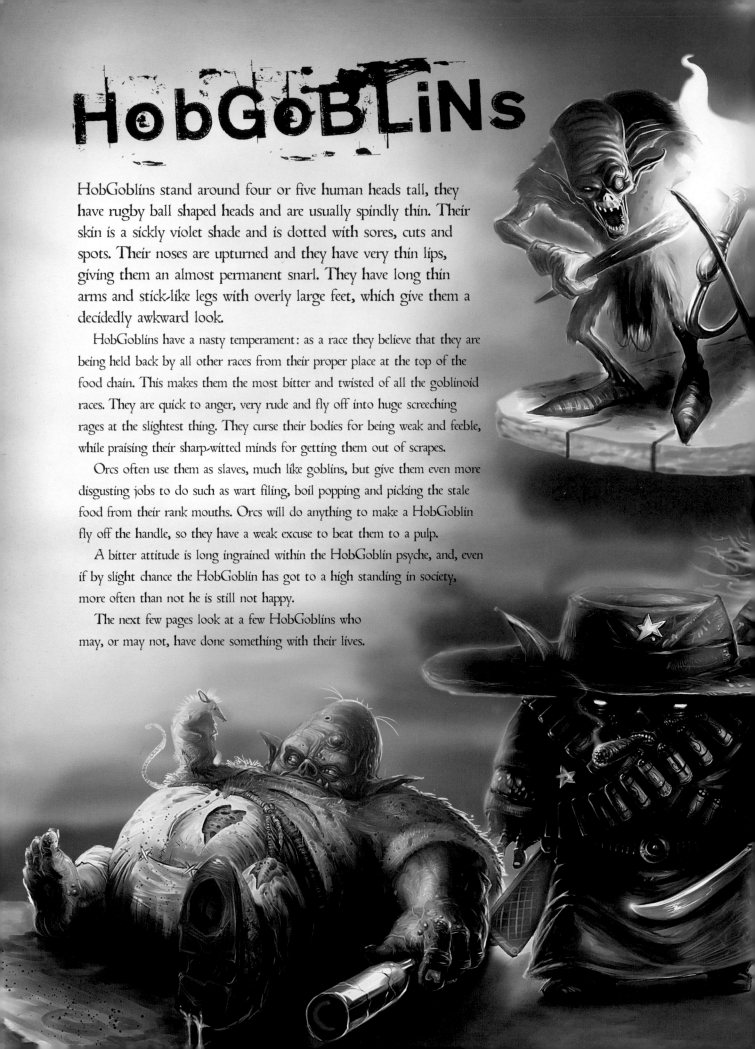

HobGoblins

HobGoblins stand around four or five human heads tall, they have rugby ball shaped heads and are usually spindly thin. Their skin is a sickly violet shade and is dotted with sores, cuts and spots. Their noses are upturned and they have very thin lips, giving them an almost permanent snarl. They have long thin arms and stick-like legs with overly large feet, which give them a decidedly awkward look.

HobGoblins have a nasty temperament: as a race they believe that they are being held back by all other races from their proper place at the top of the food chain. This makes them the most bitter and twisted of all the goblinoid races. They are quick to anger, very rude and fly off into huge screeching rages at the slightest thing. They curse their bodies for being weak and feeble, while praising their sharp-witted minds for getting them out of scrapes.

Orcs often use them as slaves, much like goblins, but give them even more disgusting jobs to do such as wart filing, boil popping and picking the stale food from their rank mouths. Orcs will do anything to make a HobGoblin fly off the handle, so they have a weak excuse to beat them to a pulp.

A bitter attitude is long ingrained within the HobGoblin psyche, and, even if by slight chance the HobGoblin has got to a high standing in society, more often than not he is still not happy.

The next few pages look at a few HobGoblins who may, or may not, have done something with their lives.

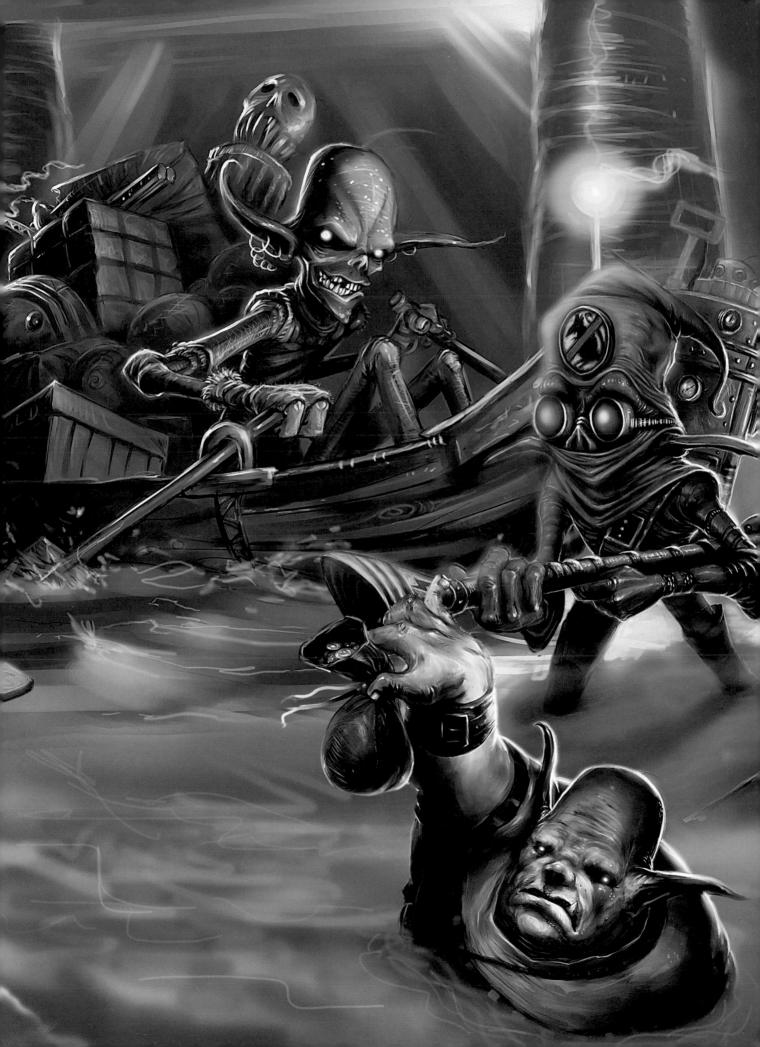

pickpocket

Melgin Barrenpurse

Melgin is a very stupid and totally lousy pickpocket. Due to his immense weight and short legs, Melgin gets caught quite often, as he can't run far or fast enough to get away. He is a huge joke around town where everyone knows his game, as he's been up in the stocks so many times that they have all thrown rotten vegetables at him at least once. In fact, he's a bit of a celebrity nowadays and most goblinoids are happy to toss him a coin for the hilarious memories he has given them. Whether he has been given money like this, or has managed to pick a pocket successfully, he spends every last penny on 'grog' and food, and lots of it.

So, the cycle is set for many years to come with the harmless but grumpy-looking Melgin puffing around with a face full of rotting vegetation and drinking with the locals – what a life.

1 Consider the angle of view very carefully. It makes for an interesting image to be looking down on Melgin while he's trying to cut a purse. This extreme angle of view means that you will hardly be able to see his feet due to his girth.

2 As you develop the sketch, plot in a lighting scheme that echoes the downward view in the image, with the light coming from above Melgin. This means that his arm, legs and part of his belly will be in shadow with no detail needed, so block out the lower part of his body. The main points of focus will be the clumsy hand and his bad-tempered face.

Having the arm break through the frame gives the shape of the painting more interest and aids the foreshortening of his entire body.

3 Start to add the initial washes and blend the colours. Think carefully about your choices - here the colouring is not quite working. He needs to have a more distinctive colouring to give him more impact and substance.

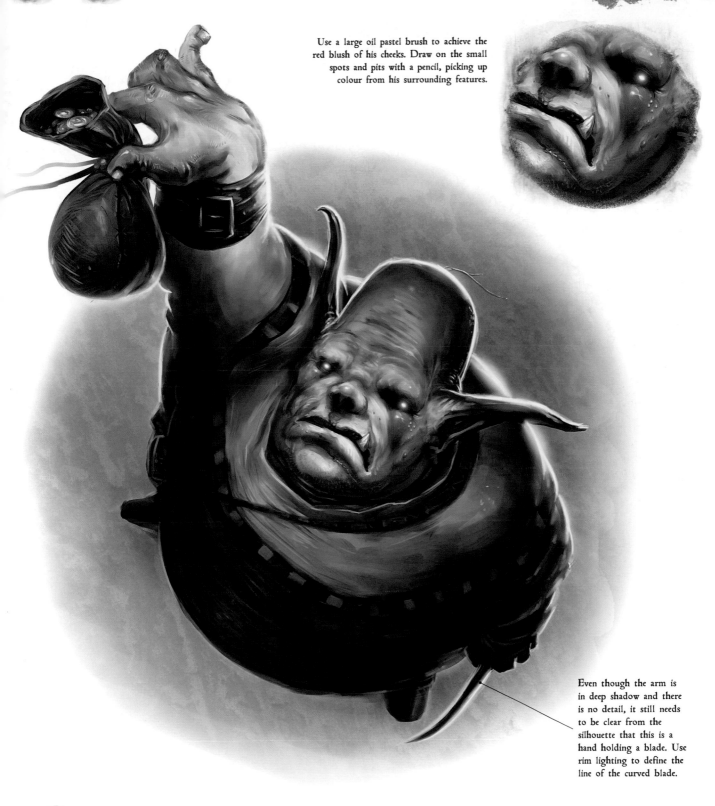

Use a large oil pastel brush to achieve the red blush of his cheeks. Draw on the small spots and pits with a pencil, picking up colour from his surrounding features.

Even though the arm is in deep shadow and there is no detail, it still needs to be clear from the silhouette that this is a hand holding a blade. Use rim lighting to define the line of the curved blade.

4 The final image demonstrates how a drastic colour change has improved the painting. The change to violet makes the brownish protuberances and blemishes on his face stand out more, while the strong green creates a pleasing contrast. Paint in a wristband to his right forearm to strengthen the downward perspective. Finally, add some light from the right to lift him off the background.

Law enforcer

Grimtooth 'Smokey' Sharpshoot

Grimtooth is 'The Law' in The Westunlands, which is an immense achievement for anyone, let alone a 3ft tall hobgoblin. In his youth he found he was a master with the blade and quickly made a profit as a small-time assassin working for the criminal underworld in major cities.

On his last job as an assassin he was almost blasted to pieces by his target's prized possession, a 'Kaboomerstick'. Fortunately he escaped with his life and the diagrams that explained the construction of this device.

He then took his wealth and his newly created Kaboomerstick into The Westunlands to practice his shot and to use his contacts to run smuggling routes throughout the land. After years of hard work, he is now the king of the underworld.

2 Develop the sketch in as scribbly a manner as you like. Think carefully about your use of shadows and highlights and try to plot these into your sketch. A menacing look is needed for this character and can be achieved by keeping his face in shadow with his eyes glowing.

1 Grimtooth is especially short, so emphasize this by making him very stocky in proportions, using square shapes for his legs and torso and giving him no neck. Try to give him the look of a bandito, with his head almost completely covered by a large hat.

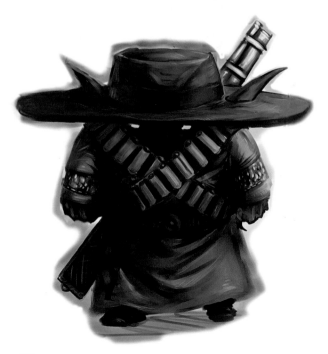

3 Start adding and blending the colours – dirty browns and yellows mostly. At this stage don't worry too much about the highlights or the details in his costume and face, but concentrate on creating the shape of the figure and his weapon, bullets and hat.

In the previous stages his face was entirely blacked out except for his eyes. For the final image, highlight any features that you want to be 'just' visible. Gently pull his features out, building them up as you go, using more saturated violets and greys.

Create the smoke from the cigar by using a large, soft round brush. Build up the smoke with each stroke until you are happy with the result.

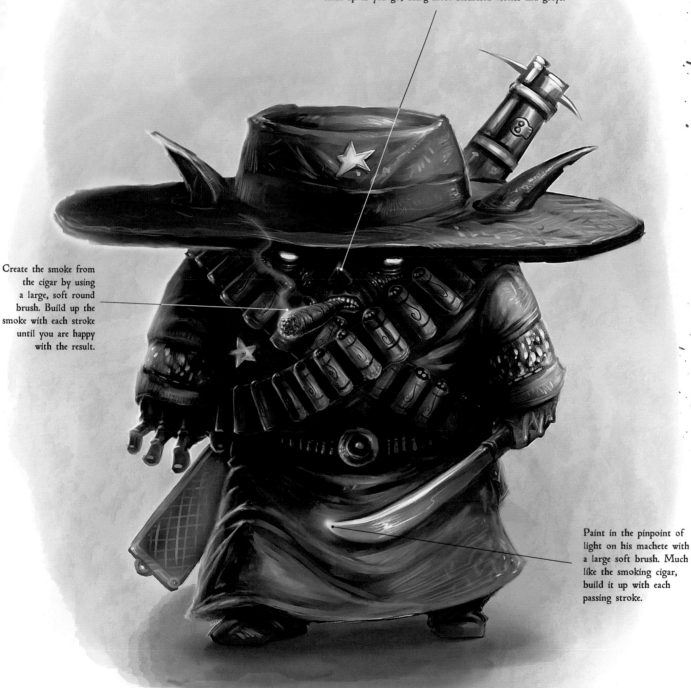

Paint in the pinpoint of light on his machete with a large soft brush. Much like the smoking cigar, build it up with each passing stroke.

4 For the final image, add some extra elements, including a cigar to give him a little more of a Clint Eastwood feel, and a shiny blade to his left hand. Open up his empty hand to make it look as though he's about to crack his knuckles while out-staring a potential troublemaker. You can see how the highlights bring life to the character, compared with the previous stage.

tramp

Carnee Groglegump

Carnee, like many hobgoblins (and indeed humans), got too used to the grape and grain, and slowly but surely became an alcoholic. He lost his job and what little family he had and he now sits on street corners hoping that passers-by will throw him a coin or two. They all know what he'll spend the money on, so he rarely gets the funds he desires.

When he's not begging, he spends his time scrabbling through the rubbish bins looking for a drop of liquor so that he can sleep his life away. Rats seem to like him and use him as a pillow while he sleeps, but it's not mutual, and they watch carefully for the moment he wakes up as he can give a fairly hard whack with a bottle.

2 As the sketch develops, try to bring out the sense of poverty and grime. Give him a dishevelled air, with one shoe with a large hole in it, and place him in a puddle.

1 Use the initial shapes to establish him lying on the floor with his bloated belly at the fore, his hand on a bottle ready to whack the rat sitting on him. This makes a nice little scene, showing the relationship between Carnee and the rat.

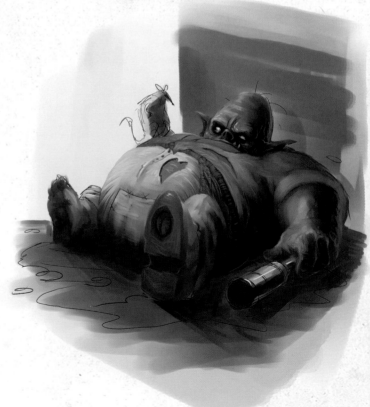

3 Begin to wash in the dirty colours and add more detail to his clothing, creating a tear in his trousers through which you can see his characteristic hobgoblin purple skin. Now is the time to experiment with elements in the composition - here I loosely tried out having Carnee's head resting against a wall.

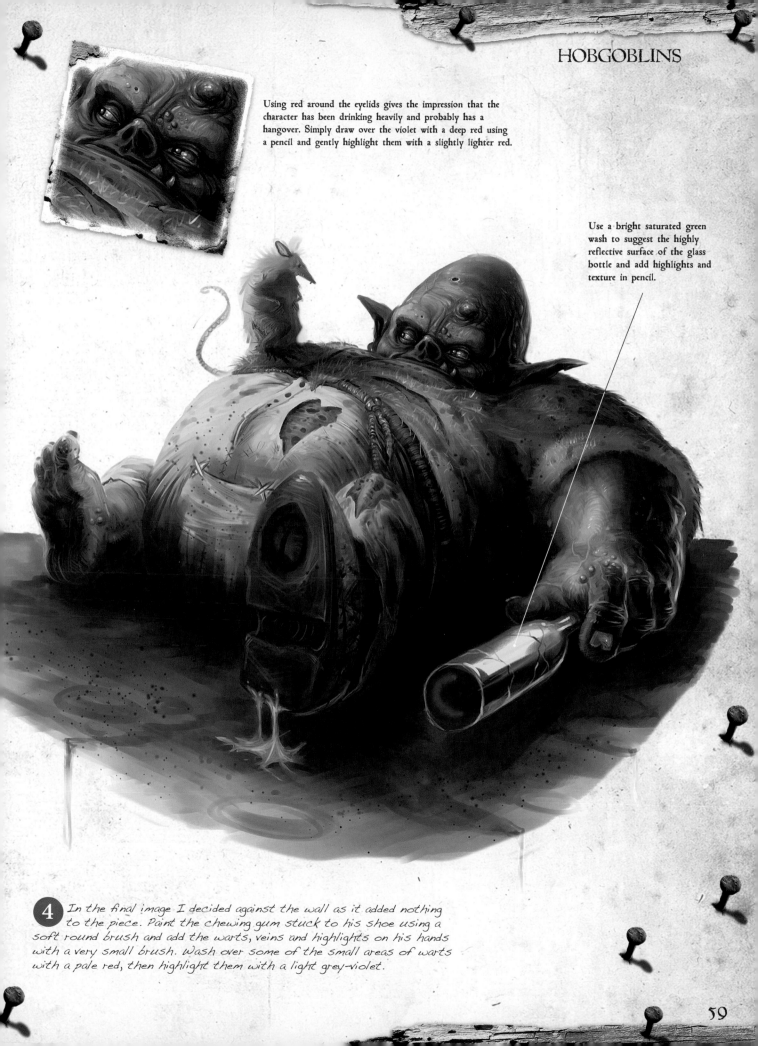

Using red around the eyelids gives the impression that the character has been drinking heavily and probably has a hangover. Simply draw over the violet with a deep red using a pencil and gently highlight them with a slightly lighter red.

Use a bright saturated green wash to suggest the highly reflective surface of the glass bottle and add highlights and texture in pencil.

4 In the final image I decided against the wall as it added nothing to the piece. Paint the chewing gum stuck to his shoe using a soft round brush and add the warts, veins and highlights on his hands with a very small brush. Wash over some of the small areas of warts with a pale red, then highlight them with a light grey-violet.

smuggler

Otis Darkweavle

Otis is the contact under the jetty on the Agein Sea, where all of the smuggled items are shipped to and from. He rows the items from the waiting ships and back to their buyer at the jetty.

He is a crafty little hobgoblin, always one step ahead of the law. With his fingers in every pie he has contacts everywhere. He works only under the light of the moon and always keeps an eye out for potential trouble that can be stifled with a dagger to the heart. His venture is too profitable to let anyone get in the way.

Quite often he will ship in rare and exotic magical items. These are handled with extra care for the client, with a further cost attached.

Although he has a very vicious nature it is obvious to any of his business partners that if you look after him, he'll return the favour ten-fold. If you scratch his back, he'll massage yours.

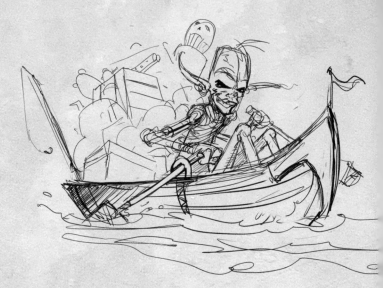

2 Continue to add detail to the scene in pencil, enhancing the sense of movement through the addition of waves created by his oars and the wind blowing his hair and ears.

1 Placing Otis in his boat ready to unload at the jetty seems to be the best plan for this painting. He needs to be shown grinning away, having made another fine profit. Block in a quick boat shape with him sitting in it. The jetty can be added when you are happy with the pencils in the next stage.

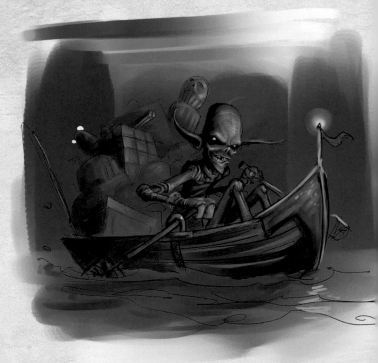

3 Choose a cool blue/green colour for the overall wash to reflect the night scene and the sea, and decide on your major light sources now. Here I have picked out two light sources: one at the front of the boat that is pale blue in colour and a bright yellow light at the rear, coming from the statuette. Roughly plot in the shape of the jetty in the background to act as a frame to the image.

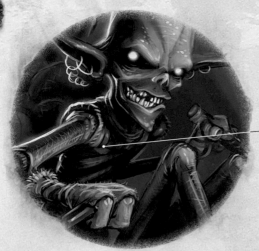

Leaving pencil marks visible in the final painting can be useful in enhancing texture. Just make sure the marks are not completely black as if there are a lot of them they can make your painting look flat.

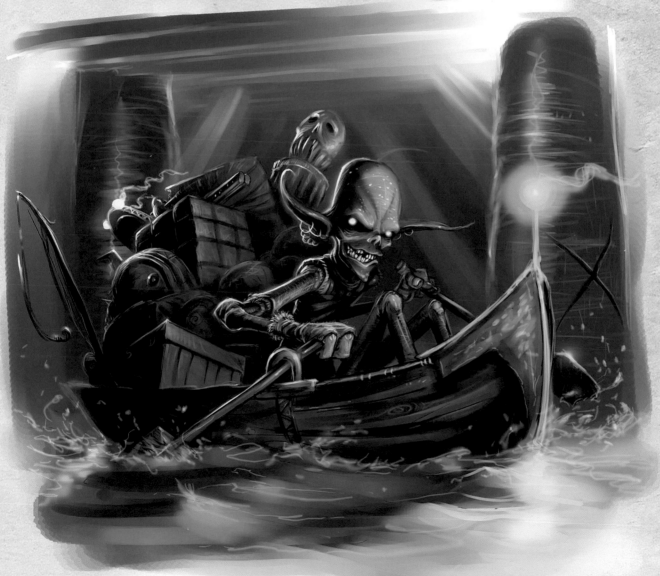

4 Here you can see how the two major light sources give form to Otis, his smuggled items and the jetty. Use light and shadow to 'carve' the shape of the jetty post - see how the light hits one side and fades to dark giving a 3D effect. The final details are to add a glint in his eyes, splashes of water to show he is rowing and the lights trailing to the right to give him more motion. X marks the meeting spot on the jetty.

tunnel rat

Tailtoe Mushnroo

When Tailtoe was a young hobgoblin, his mother left him alone in a sewer tunnel near the outskirts of Demerna. She said she would be back soon and headed deeper into the tunnels. He waited for days but she never returned. Somehow he survived, living off the scraps in the tunnel system, watching the rats and learning how and where they found their food. Eventually he seemed to befriend the rats and they accepted him until one day, deep in the tunnels, he found them chewing on a corpse. Lying there, face down and with its body half eaten, he recognized it immediately as his mother and he was thrown into an insane rage. At that very moment he swore he would kill every last rat he came across.

When he was finally captured by the Demerna Sewer Repair Team they sentenced him to clearing the sewers of rats using a new-fangled Suckupamachine – he was ecstatic.

Suited up in his tight leather gear, he patrols the sewers vigilantly, sucking up any rats he sees.

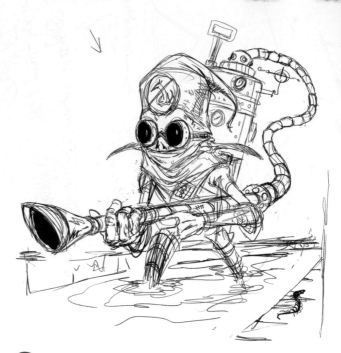

2 Mark in an arrow where you want the light to come from. However for this image I also wanted some light to come from behind him which you'll see in the final step. Add dials and a pump to the Suckupamachine, and make sure his goggles and head badge are clear to see.

1 Having a clear vision is vital in creating a striking image. I knew exactly what I wanted to do with Tailtoe, so I pencilled in the first shapes to have him wading through sewage towards the viewer with his Suckupamachine in hand and strapped to his back.

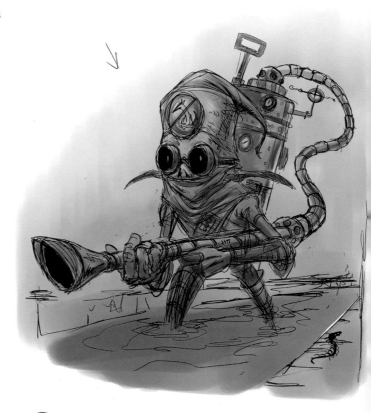

3 Wash in some very basic shades of yellow/ green and grey, again showing the light coming from the front. This colour will give you the basis for your colour choices in the next step.

With rim lighting - caused by a strong backlight - the effect is stronger where the surface is more reflective, on his shoulder and ear in this example.

Adding rats' tails coming out of the end of the machine provides a strong story-telling element, which works in combination with the badge on his hat, reminding us what his job is.

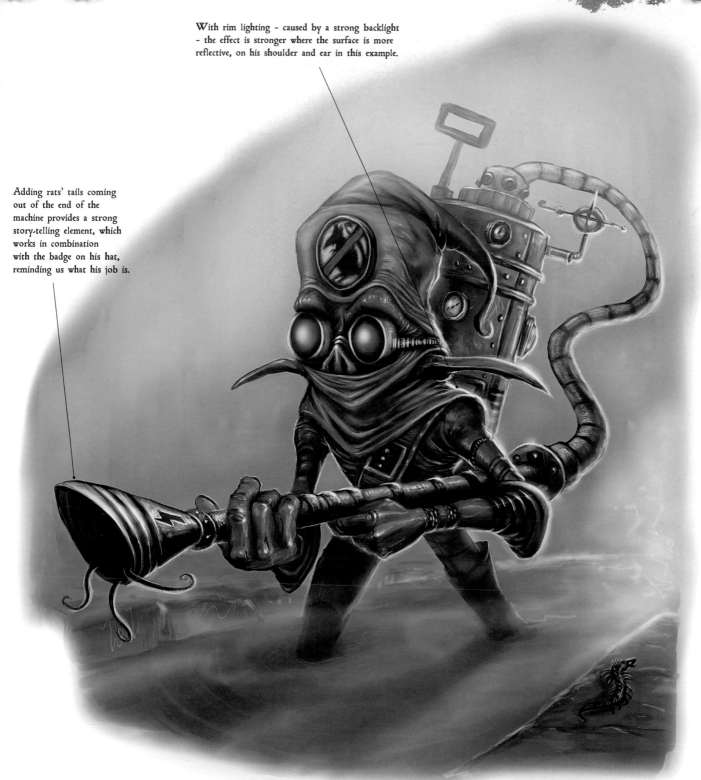

4 Having washed in the grey-green in the previous step, now wash in some deeper greens for his suit and equipment and violet for his skin. Create a stronger light coming from behind him by washing in a yellow source light using a large soft round brush. With the same brush, add the rim light to his right side of his body and equipment, making sure to pinpoint light on the more reflective parts. Finally, add some wriggly rats' tails to his Suckupamachine; they are the fat ones that got stuck!

torturer

Binter Hotpoker

For many, many years Binter was a plaything of orcs, and was often tortured with a hot poker. He was thrown off a cliff by the orcs and left for dead. Fortunately (or not), Binter survived and dragged his crushed body under the cover of nearby trees.

Some days later he was found by a group of human highwaymen. They dragged him roughly on to the back of a horse and took him to their camp.

Months and months passed, but finally Binter's wounds scarred over. After talking with Binter about his experiences, the highwaymen offered him the job of Grand Torturer, suggesting to him that he could get his wicked revenge with those very same hot pokers that were used on him. Naturally, he jumped at the chance.

1 Binter's body is broken and battered, so give him a massive hunch, as though his body never recovered from the orcs' beatings. Also give him a hook where his hand was cut off, a bulbous eye where it was scratched and scraped and a large hot poker, his new-found toy, which clearly gives him great pleasure to use.

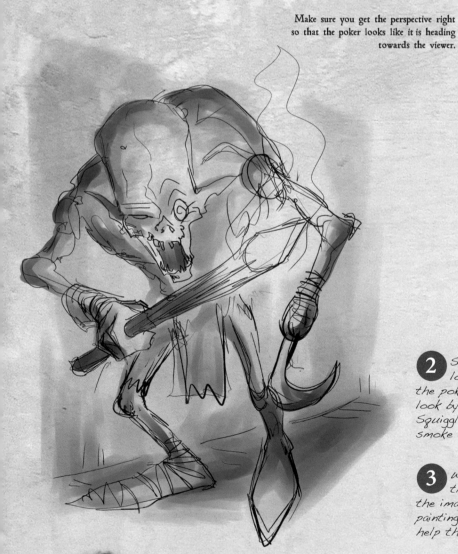

Make sure you get the perspective right so that the poker looks like it is heading towards the viewer.

2 Start to add detail to the sketch, adding a loincloth-type garment and a glove to hold the poker. You can also give him a slightly crazed look by drawing in a swirl within his bulbous eye. Squiggle in some rough lines where you want the smoke and light from the hot poker to go.

3 Wash in the first tones, making sure that the end of the poker is the lightest part of the image, as you want it to be glowing in the final painting. Also wash in the shadows roughly to help the contrast between light and dark.

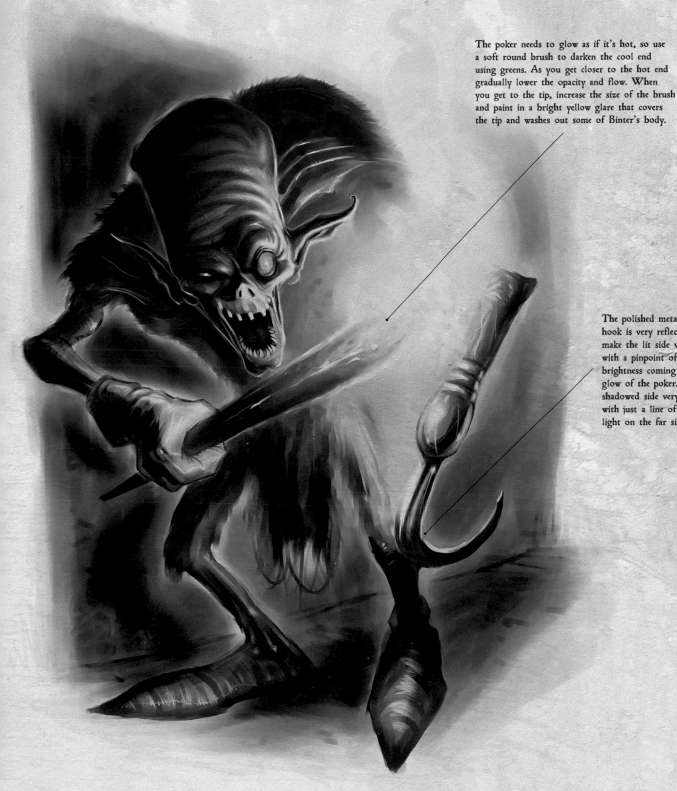

The poker needs to glow as if it's hot, so use a soft round brush to darken the cool end using greens. As you get closer to the hot end gradually lower the opacity and flow. When you get to the tip, increase the size of the brush and paint in a bright yellow glare that covers the tip and washes out some of Binter's body.

The polished metal of the hook is very reflective, so make the lit side very bright, with a pinpoint of equal brightness coming from the glow of the poker. Keep the shadowed side very dark, with just a line of reflected light on the far side.

4 Give the background a dirty blue/grey wash and give Binter the signature grey-violet flesh tones. The light and smoke from the poker are fun to do; blob in some highly saturated orange at the point to give it some texture while the rest of the area around that is a very pale, bright yellow. The closer the poker gets to his hand the cooler it becomes so graduate the colours and darken the tones using a grey-green. Finally, wash over his bulbous eye with a bright green to help his mad face stand out against the glare.

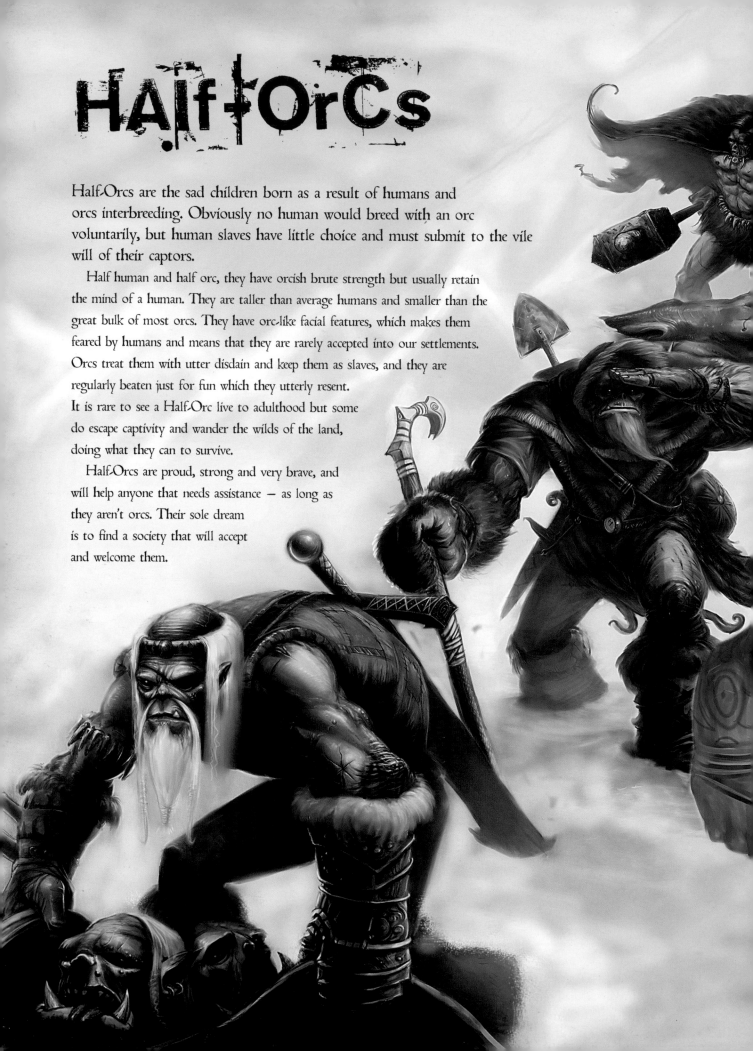

Half Orcs

Half-Orcs are the sad children born as a result of humans and orcs interbreeding. Obviously no human would breed with an orc voluntarily, but human slaves have little choice and must submit to the vile will of their captors.

Half human and half orc, they have orcish brute strength but usually retain the mind of a human. They are taller than average humans and smaller than the great bulk of most orcs. They have orc-like facial features, which makes them feared by humans and means that they are rarely accepted into our settlements. Orcs treat them with utter disdain and keep them as slaves, and they are regularly beaten just for fun which they utterly resent. It is rare to see a Half-Orc live to adulthood but some do escape captivity and wander the wilds of the land, doing what they can to survive.

Half-Orcs are proud, strong and very brave, and will help anyone that needs assistance — as long as they aren't orcs. Their sole dream is to find a society that will accept and welcome them.

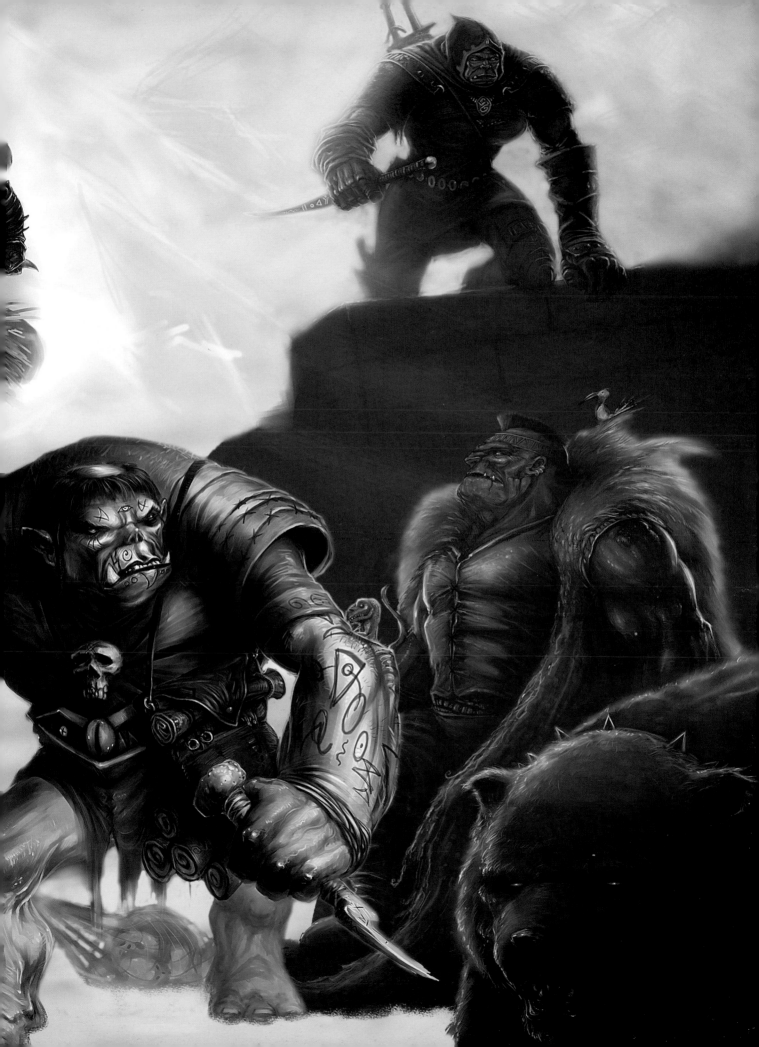

animal tamer

Shenshik the Lonely

Shenshik lives in the wilds of Caramor Forest, where he has found peace through his affinity with nature and his innate ability to befriend animals. Despite his size and his ferocious appearance, little creatures perch happily on his shoulders, knowing that he will be gentle with them. A giant brown bear, Meeshu, is his constant companion and together they fight off any threat to the forest and its creatures from orcs, trolls and ogres.

After many battles, Shenshik is now feeling his age. His scarred body is slowly failing him and he knows he doesn't have much longer in this world. He has one wish, to meet another of his race, but he knows that it will probably never happen.

1 Shenshik is aging but still very proud, so choose a pose that shows him with his chest puffed out and his chin up. Trace in the line of his long sweeping garment and place Meeshu in the foreground so that she becomes integral to the image, as she is so central to Shenshik's life.

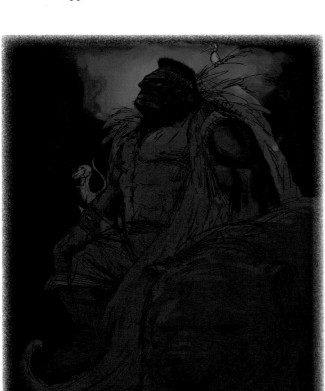

2 Quickly draw in fur and feathers, along with a few extra animals sitting comfortably on Shenshik, as this helps show his 'oneness' with nature. Try to establish a vague American Indian vibe coming from Shenshik, which his stance and costume will help to convey.

3 Lay in the darker colours first, completely filling the background with dark earthy tones. Then slowly and gradually brush in the colour of his clothing, the animals perched on him, the bear and a little of the background. Once you are happy with the colour selection, start to pick out highlights using the background sky as the light source.

Pits, scars, wrinkles and bags under the eyes are all good indicators of having led a hard life. Draw over all the details in pencil and highlight them with oil pastel brushes.

Paint the trees with a normal soft round brush and a 'blobbing' action.

To achieve the detail on the wristband, use cross hatching in orange and yellow with a fine brush, gradually increasing the pressure on the brush as you work.

To really capture the way he is bulging out of his leather shirt look for a photo reference to see how the material stretches or, better still, get a friend to model for you.

4 For the final image use lots of soft lighting and lighten it considerably from the previous stage, leaving the bear very dark for contrast. Add a clear sky and a suggestion of trees in the background to create some interest in the image frame. Make sure Shenshik's face is lit and saturated to draw your eye to his scarring and grim expression. Use rim light to separate Shenshik from Meeshu to prevent them blending into each other.

barbarian

Meskin Dragonslayer

Meskin escaped his orc slavers as a child and fled to the mountain regions. There, he wandered alone for many years, braving the harshest of conditions and fighting off the most terrifying creatures with nothing but his own brute strength and a massive war hammer he found on his travels.

One day a handful of barbarians from a proud and honourable tribe found Meskin's tracks. Curious as to what humanoid could be so large as to have almost twice the stride of a human, and also to discern whether or not it was a danger to them, they followed them. After days of tracking Meskin, the barbarians were set upon by an evil ice dragon called Eskia. They stood no chance but luckily Meskin heard the battle and came to the rescue. After a titanic fight between the two, Meskin delivered the fatal blow, directly between Eskia's eyes. The barbarians were awed and made Meskin an honorary member of their tribe, giving him the name 'Dragonslayer'.

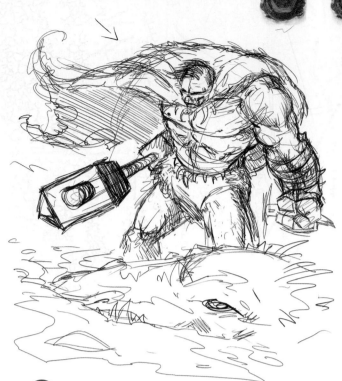

2 Work more over the initial shapes to get the musculature clearly defined on his arm and shoulder. Draw him holding one of the dragon's teeth to imply he has taken a trophy after slaying it. Add an arrow to the drawing to indicate where you want the light to come from.

1 Having fought in the mountains since his youth, Meskin would have massive broad shoulders. He'd also have fur clothing to keep himself warm, so sketch in a quick fur cloak blowing in the wind. Plot in the dragon's head at his feet with him looking down on it.

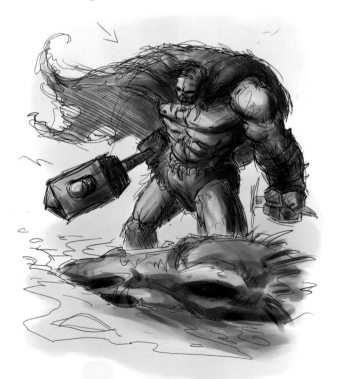

3 Start laying in the colours on top of the sketch, giving Meskin a typical goblinoid green colour. Where you indicated the light direction in the last stage, make sure you carry this through and paint the darker, shaded tones to the right of the image, as shown here.

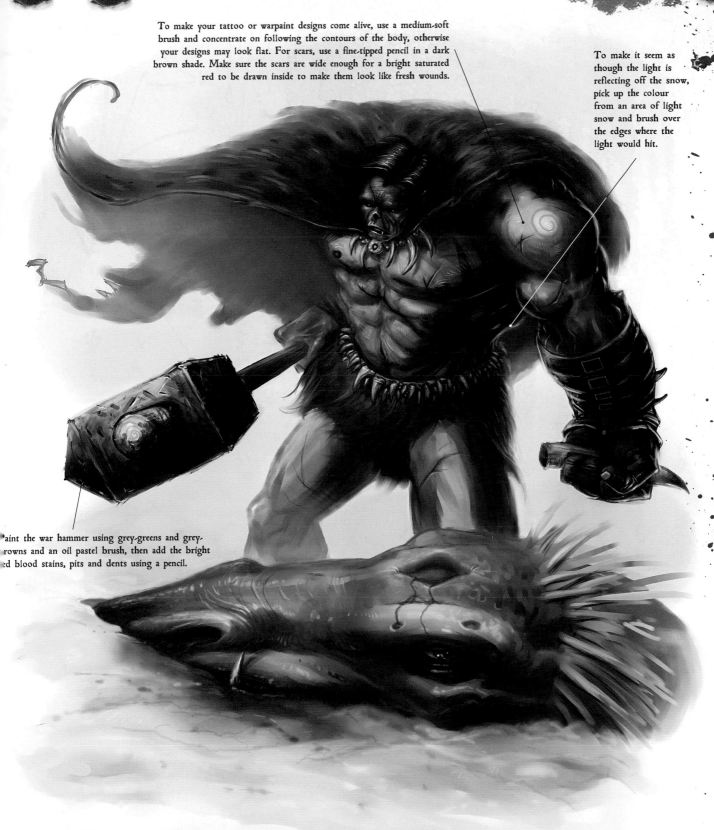

To make your tattoo or warpaint designs come alive, use a medium-soft brush and concentrate on following the contours of the body, otherwise your designs may look flat. For scars, use a fine-tipped pencil in a dark brown shade. Make sure the scars are wide enough for a bright saturated red to be drawn inside to make them look like fresh wounds.

To make it seem as though the light is reflecting off the snow, pick up the colour from an area of light snow and brush over the edges where the light would hit.

Paint the war hammer using grey-greens and grey-browns and an oil pastel brush, then add the bright red blood stains, pits and dents using a pencil.

4 For the final image add tattoos, warpaint and scars and greatly increase the level of detail in his costume. Add blood stains to his war hammer, the dragon and the snow to show there has been a brutal battle. Try developing his hair to give him a more traditional human haircut, which helps emphasize his half-human origins.

mage hunter

Gretchin Runecrusher

Mages are creatures that control the magic that flows around the world, enabling them to cast fireball spells, freeze time and summon demons.

Gretchin hates mages, having watched her sister burn to death at the hands of a mage and you can't blame her. She swore allegiance to the Church of the Runecrusher whose publicly decreed mission is to slay all mages because of their wicked and unholy ways. The Church elders supplied her with an amulet that cloaks her from a mage's supernatural sight, a dagger that can kill with a scratch and a hood to protect her from the blast of spells.

Using her stealth and ingenuity she was successful for many years and praised by the Church, until she discovered that the very people who employed her were secretly mages themselves. The Church elders did not realize that she had discovered their lie until it was too late and they were hunted down one by one and killed, using the very items they had given her.

1 *Gretchin is climbing over a wall, hunting down her prey, so block in a simple stone brick shape for her to be clambering over.*

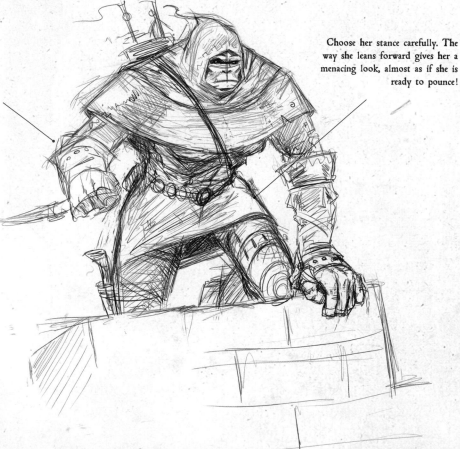

Draw her leaning forward slightly, holding her dagger.

Choose her stance carefully. The way she leans forward gives her a menacing look, almost as if she is ready to pounce!

2 *Sketch in the additional costume elements such as her dagger and hood, and think about the atmospheric lighting - this image will be lit by moonlight but don't be definite about the placement of the moon just yet.*

3 Wash over the entire figure and background with a deep red-brown, then slowly start to add lighter areas with large soft brushes, which will help you to control your colour values more easily. Gradually work to smaller brushes to pick out the details.

Create interesting designs within your image, such as the strange symbol used on the amulet here. This suggests a hidden meaning that adds to the intrigue of the piece.

4 Add the moon and give it a nice glow with a large soft brush. Finally, add the highlights to Gretchin, making the moonlight fall on her head and shoulders in the main, to draw the viewer's eye to these areas in particular. Use the same coloured light to rim-light her dagger and to paint the symbols on it.

Give her ice blue eyes to reflect the moonlight and her cold character using a pencil with a very fine point.

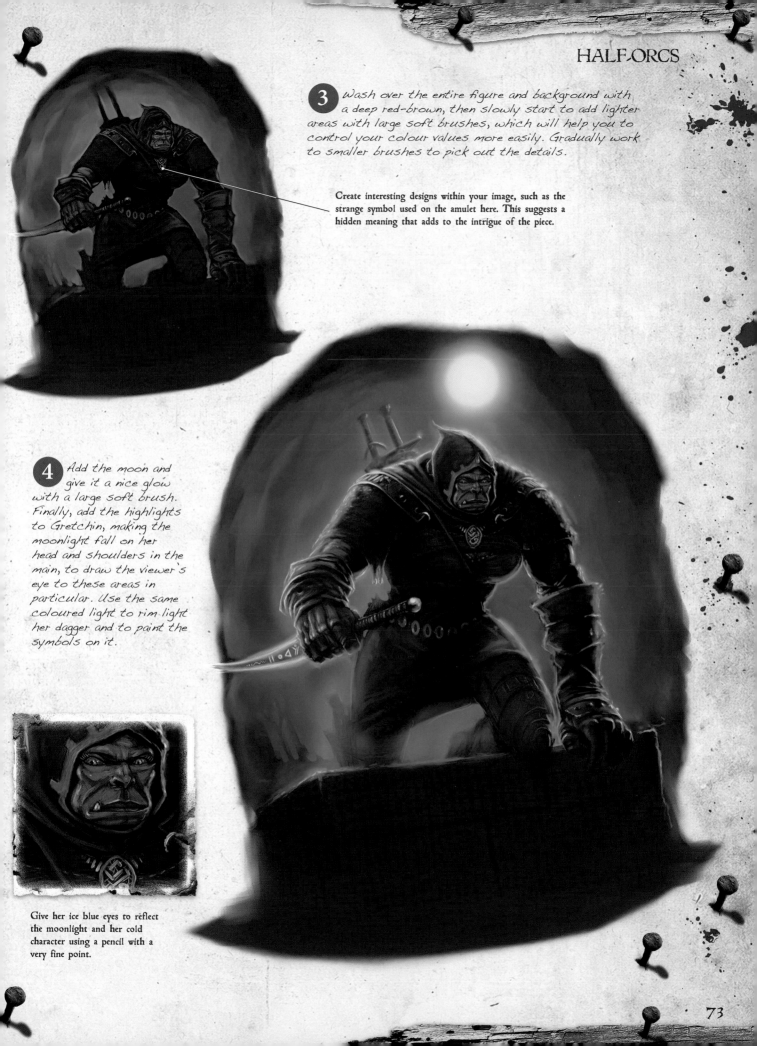

orc slayer

Sinzei Pewthohr

Sinzei doesn't remember his past. It is far too long ago in a hazy mist of anger and fear for him to see clearly. He isn't totally sure how he came about his profession of orc slayer but knows that he loves his work and serves his Master well.

He can't remember what his Master looks like either, even though he had an audience with him just five minutes ago. Actually Sinzei wonders about a lot of things, especially about the band upon his brow that seems to be glued to him … has he tried to remove it before? Is it this that makes him forget things? He is troubled by voices whispering in his head and sometimes loud ones telling him to stop fighting. But he ignores them and continues to serve his Master loyally, hunting down and killing orcs wherever and whenever he can.

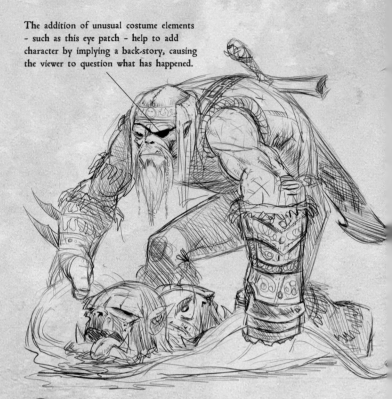

The addition of unusual costume elements - such as this eye patch - help to add character by implying a back-story, causing the viewer to question what has happened.

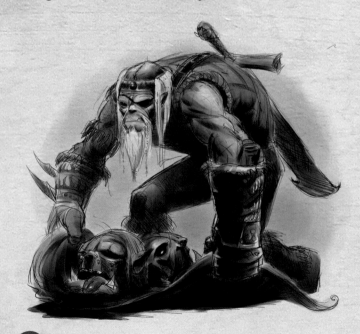

2 As a hunter he needs to be wearing light armour, so begin to sketch in some fur and leather which suits his character well. Include glove spikes for slitting orcs' throats in close-quarter combat.

1 The vision for this image is that Sinzei will be presenting two slain orcs' heads to his Master. His Master is a mystery to us so he is off screen. Sketch in the basic shapes of Sinzei leaning forward, almost bowing, while unfolding a cloth wrapped around the heads.

3 Select a lighting direction coming from above so that the heads of the orcs will pick up the lighting from above and will stand out against the dark shadow of Sinzei's body. In the initial wash, keep the top of each surface lighter with the underneath in shadow. Scribble in a few markings as a guide for his scars and rough up his elbow, ready for the next step.

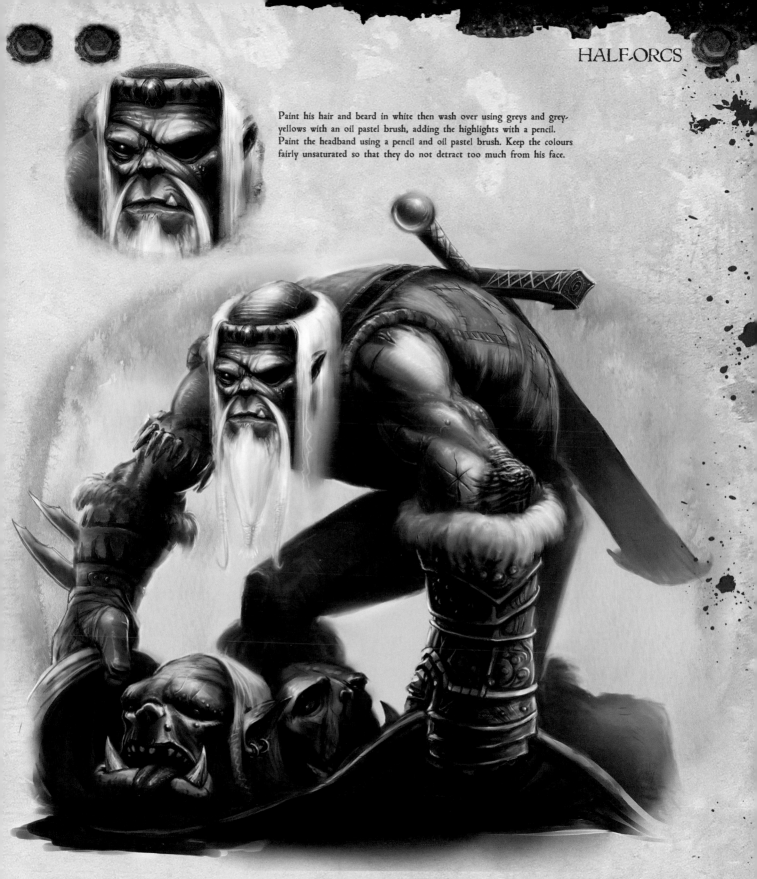

Paint his hair and beard in white then wash over using greys and grey-yellows with an oil pastel brush, adding the highlights with a pencil. Paint the headband using a pencil and oil pastel brush. Keep the colours fairly unsaturated so that they do not detract too much from his face.

4 Blend the colours together and give a slight blue/grey textured shading to the background, with his sword and trailing leg fading out. All the detail in the image should be kept in the foreground to draw the viewer's eye here. Paint and blend the orc heads using an oil pastel brush, then use pencil to add any highlights and details like the spots, nose highlights and scars.

mountain wanderer

Reskin Lonewalker

Reskin wanders the Oggish Mountain ranges, looking out for adventurers in need of aid from goblinoid raiders, rescue from freezing snowstorms or a little company over the arching mountains. He is a loner, happy in his own company but happiest when slaying evil goblinoids, which he does whenever he gets the opportunity.

He has taught himself survival in the harshest of winters on the mountains. While others would wither and die, he is strong and fit, dwelling in his cave and subsisting on his infamous hot goblin-brain broth. It is not the most appetizing meal but one that supplies him with most of the nutrients he needs.

2 Reskin needs a fair amount of equipment to aid in his survival. Add a large pouch and a knife to his hip and a pack and shovel on his back. Create the sense of a windy environment by making sure his fur, beard and hair are blowing in the wind. Draw his feet half submerged in the deep snow. Try to decide on the lighting direction (you can try more than one light source).

1 Reskin is a wanderer by nature so it seems fitting to have him walking towards the viewer, looking out into the distance and holding a walking staff.

3 Lay in the initial washes, using a grey-blue/violet for the snow, browns and greens for the fur and cloth and an ashen grey colour for his skin. Where the light hits his body use very pale yellow and cyan which give the appearance of being in a snowy lit area.

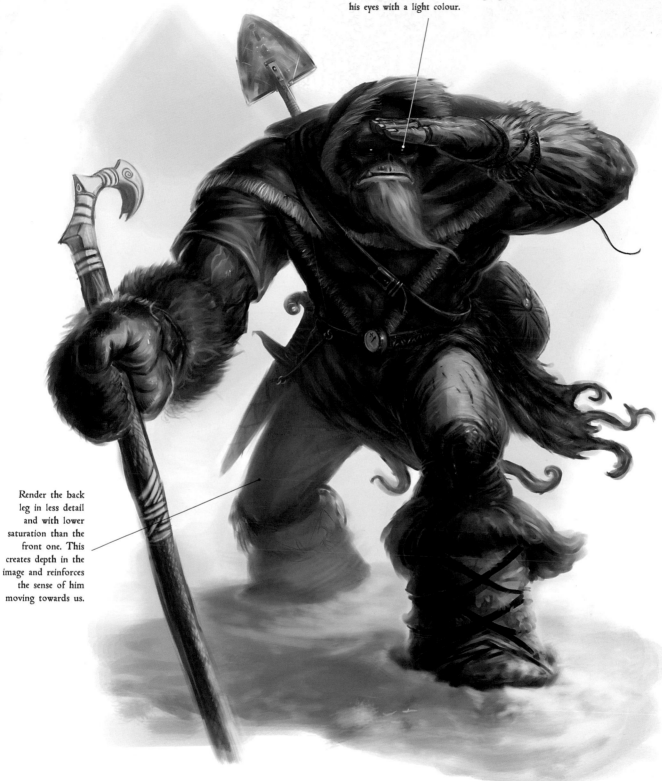

As his hand is raised, use violet shadows to cover most of his face then highlight his eyes with a light colour.

Render the back leg in less detail and with lower saturation than the front one. This creates depth in the image and reinforces the sense of him moving towards us.

4 Blend in all the colours as you paint, still making sure that the loose material is blowing smoothly to the right. Add some final details, including a compass on his belt to help him navigate through snowstorms. Paint in the snow and background roughly with large smooth brushes, to give just a hint of snow and atmosphere.

rune Scriber

Riszle Crowspine

Riszle is more orc than human. He does retain human intelligence but his mind is warped by orcish tendencies. His aptitude led him to learn the art of writing but unfortunately for humans his preferred scribing tools are bones and his favourite paper is skin, so woe-betide anyone who crosses his path.

He lives high up in the mountains between Marabelle and Demerna. From his vantage point he can view the human traders travelling between the two cities and pick out his victims. He will sit for hours skinning his prey to create whole reams of paper and carefully crafting writing tools from their wretched bones.

He carves runes on the small trail that leads up to his home, on the rocks around his cave and on himself to ward off enemies finding him, so that he is left in peace to perfect his studies.

1 Riszle is clearly a nasty character, so depict him walking forwards, leaning towards us with his hunched back up, weight on his left foot and with one of his favourite writing implements on show – a femur from one of his victims.

Give him a monk-style haircut to make a visual reference to ancient scribes – though this one is clearly less than godly.

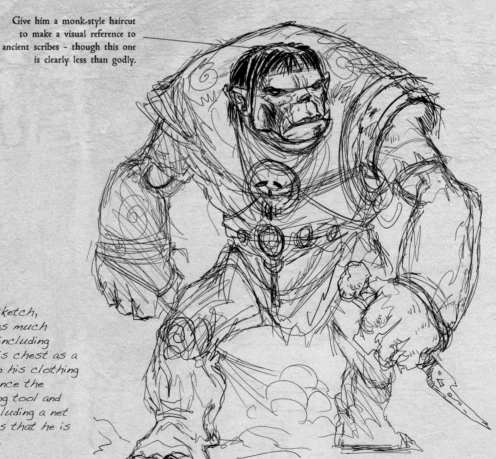

2 Develop the sketch, bringing out as much detail as possible, including adding a skull on his chest as a prize and plotting in his clothing and large belt. Enhance the shape of his writing tool and create depth by including a net of skulls and bones that he is dragging behind him.

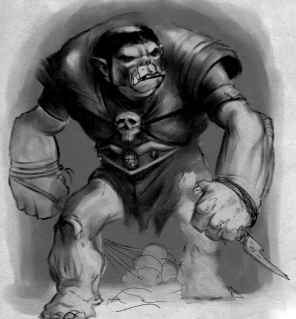

3 Start to wash in and blend the colours. He's a cold character so choose a grey-blue colour for his skin, and a cool blue-green for the background. Begin to think more about the lighting. For such a nasty creature, there needs to be a certain darkness to him which will have to be built up for the final image.

4 Work on the lighting more, until you are happy with the contrast in the final piece. Increase the level of detail significantly, adding a bag of decorated skin scrolls and the rune marks on his own skin, which add to his character. Create the carvings in his face using a pencil, drawing the shapes and symbols using a dark brown or red. Then gently wash over with a bright red using an oil pastel brush. Finally, add the highlights with a pencil in bright yellows and cyan.

The crystal jewel on his belt reflects light, picking up the blue-green from the background as well as the yellow light. To get this effect, wash over it with blue-green on the left side then highlight it with pinpricks of bright saturated yellow on the right. Finally, add a fine point of bright blue-green on the left.

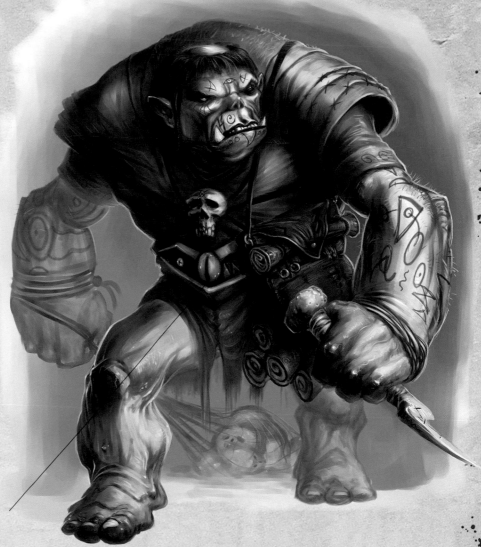

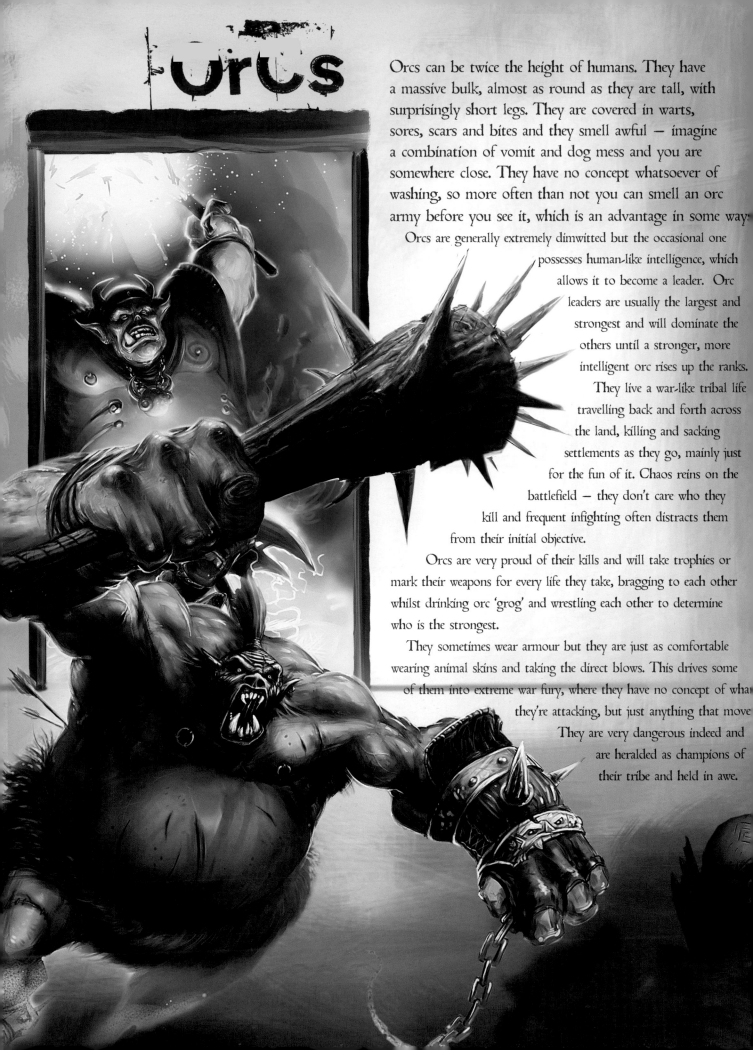

Orcs

Orcs can be twice the height of humans. They have a massive bulk, almost as round as they are tall, with surprisingly short legs. They are covered in warts, sores, scars and bites and they smell awful — imagine a combination of vomit and dog mess and you are somewhere close. They have no concept whatsoever of washing, so more often than not you can smell an orc army before you see it, which is an advantage in some ways.

Orcs are generally extremely dimwitted but the occasional one possesses human-like intelligence, which allows it to become a leader. Orc leaders are usually the largest and strongest and will dominate the others until a stronger, more intelligent orc rises up the ranks. They live a war-like tribal life travelling back and forth across the land, killing and sacking settlements as they go, mainly just for the fun of it. Chaos reins on the battlefield — they don't care who they kill and frequent infighting often distracts them from their initial objective.

Orcs are very proud of their kills and will take trophies or mark their weapons for every life they take, bragging to each other whilst drinking orc 'grog' and wrestling each other to determine who is the strongest.

They sometimes wear armour but they are just as comfortable wearing animal skins and taking the direct blows. This drives some of them into extreme war fury, where they have no concept of what they're attacking, but just anything that moves. They are very dangerous indeed and are heralded as champions of their tribe and held in awe.

chieftain

Meggles Crusherson

Meggles is the new chieftain of the leading tribe of orcs. His father, Crusher Crusherson, recently met an untimely and suspicious end. No one knows exactly how Crusher died but the law of the tribe states that if the chieftain dies his eldest son must take his place as leader. Meggles is only 12 months old so this has caused numerous problems within the clan.

Thankfully, the priestess Orgrog (see pages 88–89) has taken Meggles under her wing, but her motives are highly questionable. The finger of suspicion points firmly at her for the death of Crusher and what she intends to do with Meggles remains to be seen.

Meggles has shown a fascination with all things morbid from birth, and his favourite toys are the battle-scarred skulls and bones of humans. If he survives infancy, he is likely to become a deeply unpleasant and very powerful orc indeed.

Paint using the 'dark to light' method – begin with the darkest tones and build up the highlights as you progress.

2 If you feel confident enough, and have a very clear idea of how you want the image to look, you can skip the pencil stage, as was done here. Lay in a dark red background and start painting Meggles in to his scene in dirty green shades, carefully working over the initial pencil marks as you go.

Use the strings that the bones are suspended from to break through the frame and add interest.

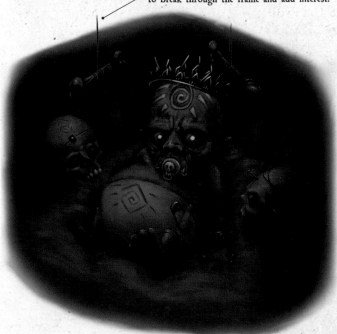

1 Human babies tend to have large foreheads and eyes and orc infants are much the same. Block in the initial shapes, making the head overly large, the body very round, and the arms and legs chubby and stunted. Show his position in the tribe by drawing in a quick crown on his head. In terms of a setting, it is most revealing to depict him in his crib surrounded by his gruesome toys.

3 Think about how you want to frame your image. As he is sitting in his crib, it works well to box him in with a vignette-style effect by gently erasing some of the background paint, leaving a soft uneven edge. Gradually add in the highlights and details as you go, working from dark to light and making sure you keep Meggles' head as the main focal point. Use a real nappy (diaper) pin as a reference in order to get this detail just right.

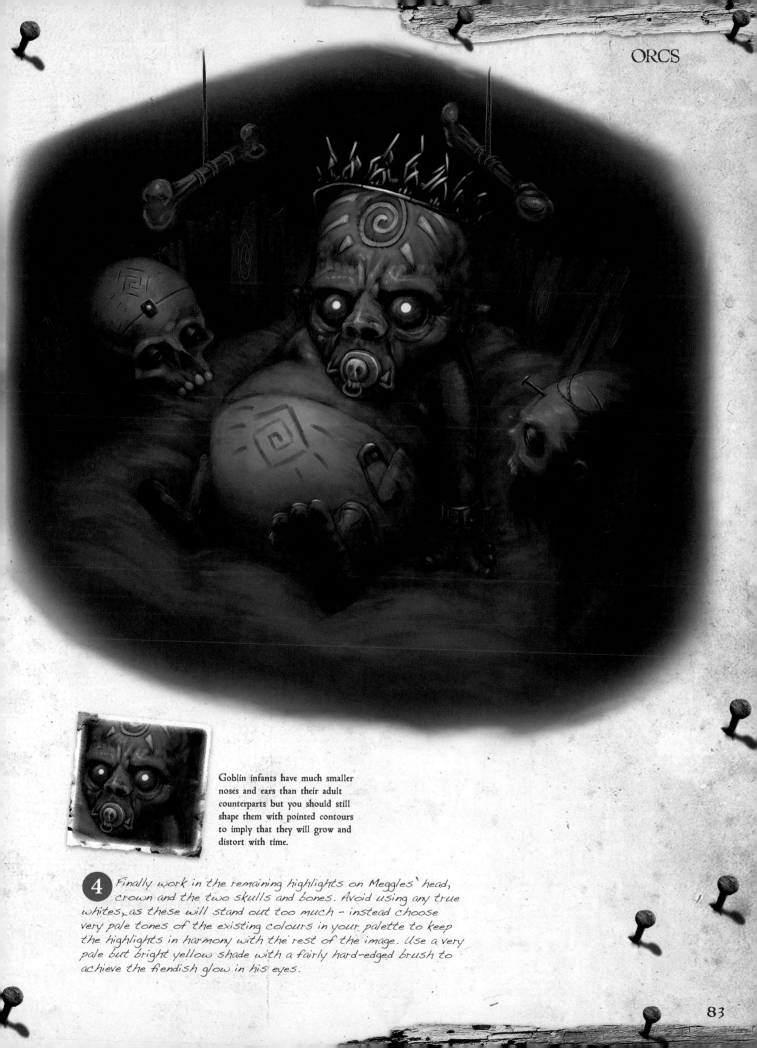

Goblin infants have much smaller noses and ears than their adult counterparts but you should still shape them with pointed contours to imply that they will grow and distort with time.

4 Finally work in the remaining highlights on Meggles' head, crown and the two skulls and bones. Avoid using any true whites, as these will stand out too much - instead choose very pale tones of the existing colours in your palette to keep the highlights in harmony with the rest of the image. Use a very pale but bright yellow shade with a fairly hard-edged brush to achieve the fiendish glow in his eyes.

rage warrior

Crunk Splitspine

Crunk was born a rather large orc; so much so that only the skins of hunted bears could fit around his ample waist. As a child he would charge into battle wearing only his bearskin pants, swinging his massive spiked club and long heavy chain.

As he grew up, his orcish testosterone levels increased with his size and he often flew into fits of rage for no apparent reason. The tribe, unable to control him or his growth, summoned the witch doctor. He concocted a brew for Crunk to drink that when digested would release his full rage only during battle, with the added advantage of making it impossible for him to feel pain. He became a massive, roaring front-line weapon for the orcs, spreading fear and terror throughout the land.

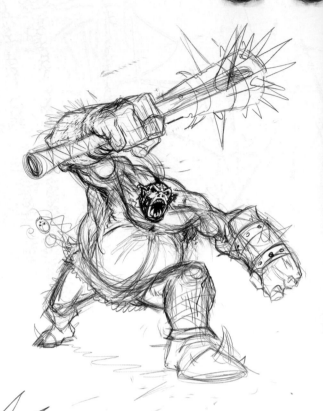

1 Once you are au fait with the basic shapes needed for your characters, you can skip the stage of blocking in the shapes to guide you and dive straight in for the sketch, as was done here. Create a pose that maximizes Crunk's enormous bulk and plays up his barbaric nature, wielding his club in a very intimidating manner.

2 While skipping the shapes stage sometimes works well, it does have its disadvantages. The leg in the foreground of the initial sketch was not working, so the image was reworked and the former back leg became the leading leg. This gives more of an impression of him being in mid-stride and leaning forwards, making it a more dramatic pose. Had this image been blocked out with shapes first, this would have become apparent earlier and time could have been saved.

A pose like this has quite an aggressive perspective - roughly blocking in some perspective lines helps to establish the vanishing point.

3 When you are completely happy with your sketch, wash in the basic flat colours and a little shading, particularly under Crunk's arms and around his enormous belly. Working from light to dark, keep the initial wash fairly transparent so that all the pencil lines are still visible - you will need these to guide you when you come to lay in the darker washes.

4 Exaggerate Crunk's terrifying nature by giving him a bright red splash of warpaint. Do this by carefully painting out half his face with a medium-sized brush and a strong saturated red colour, and then use paler shades of the same colour with a large, soft brush to tint the background. Add some deep scars to his body and some arrows stuck in his side and spend as much time as you can adding details, from the fur of his bearskin clothes to the textures on his club and details in his armour.

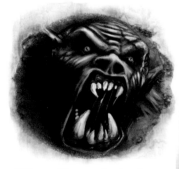

When crafting a predominantly monochrome image, the addition of red will draw the viewer's eye and send them a strong danger signal.

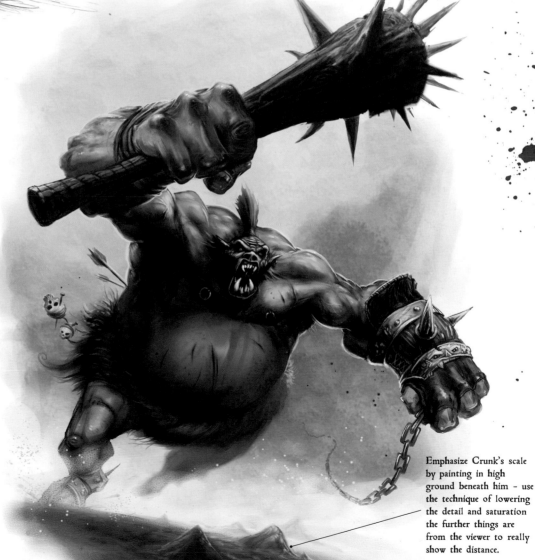

Emphasize Crunk's scale by painting in high ground beneath him - use the technique of lowering the detail and saturation the further things are from the viewer to really show the distance.

innkeeper

Ocrid Manybeers

Ocrid was once a famous adventurer, having slain ten of the most fearsome dragons in the land, as marked on his massive war axe. His fame even reached the major human settlements and they welcomed him with open (if somewhat nervous) arms into their cities.

Finally, after many months of soul-searching, he decided to hang up his dragon-slaying gloves and open up the Friendly Orc Inn.

He is now well known for being a great innkeeper who looks after his customers but who will not stand for any nonsense, kindly reminding troublemakers of what could be in store for them by pointing at his axe hanging on the wall behind him. If that deterrent doesn't work they are in serious trouble.

2 To achieve this relaxed and inviting pose, shift his weight on to his elbow and lean his body to the right. Pose yourself in front of a mirror to see how this works. Your collar bone raises where it connects to your shoulder, making your shoulder level with your chin. Because he's an orc, exaggerate this so his shoulder is level with his head.

1 Keep the image nice and simple by having Ocrid leaning on the bar with his axe hanging on the wall behind him. This instantly sets the scene and makes life easier as there is no need to draw his lower body at all.

3 If you are confident that you know what direction you're heading in with the choice of colours and lighting, wash over the background with a flat grey, then start adding the colours now, rather than using a more monotone wash over the whole image.

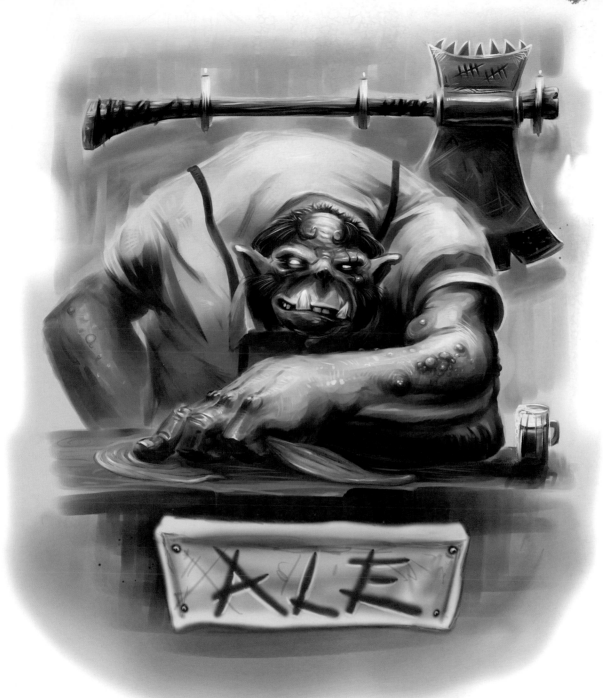

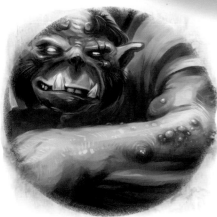

4 In the final image, add the details such as his curly hair, warts and sores, the cleaning cloth, the sign and the texture and notches on his axe, which give an indication of all the battles he has fought. Paint the notches in with a dark brown pencil. Where the light hits the edges of the notches pick up the lightest colour from his shirt and paint it on with a fine brush.

To create the warts on his skin, paint in the shapes using the normal colours of his skin, taking note that the lightest side of each wart should be the top part. Then wash over the area with a light orange colour adding pinpricks of opaque saturated yellow for highlights.

priestess

Orgrog Worttongue

Priestess Orgrog is an evil, manipulative and conniving orc. She is surprisingly intelligent for one of her race and has used this to get where she is today. She worked her way up the priestly ladder by cheating, lying and killing her competitors until she was at the top.

Her most diabolical plan yet has come to fruition. She killed the orc chieftain Crusher Crusherson by poisoning him. She then proclaimed that their god spoke to her and told her to raise his son Meggles (see pages 82–83) as her own. Even though he is still a baby, she has said it is their god's will for the son to take the chieftain's place and that through her power to commune with their god, she will be his voice.

Of course she is lying through her teeth and has every intention of killing off the child once she has established herself as the voice of god. She has decided that she will blame the ogre seer Gorgar Stumpfist (see pages 112–113) for the death of the child and then take total control of the tribe.

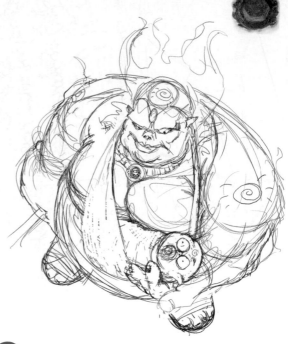

2 As you build up the sketch, try to capture Meggles' wide-eyed nervous look and spend time getting Orgrog's expression just right – like she might be considering dropping him. Loosely sketch in her hair so that it almost looks like flames, but leave any detail in the hair until the painting stage.

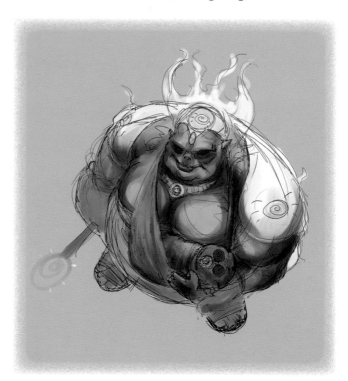

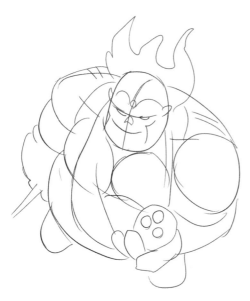

1 Orgrog is a very nasty lady, so create a pose where she is holding Meggles as if she really cared for him but with an 'oops wouldn't it be a shame if I dropped him! HAHAHA' look on her face. The expression will need refining in the next stage but for now just mark in the basics of her anatomy and where Meggles will be placed.

3 Lay in a flat grey background and then start washing in the base colours. The white for her robes is a sign of her priestly role so, to accentuate this, brush in some white mad hair too. Wash in a dirty yellow on the priestly symbols on her head and shoulders. The choker around her neck will be gold in the final image, so wash in a slightly more saturated yellow on this. Make both sets of eyes a strong red to draw attention to them.

For all her ugliness, she's definitely female, so use a dash of crude red lipstick to bring out her feminine side. Having a slightly goofy tooth showing also adds character.

To achieve the translucent, slimy appearance use a simple soft round brush and wash over with various dark shades of green, brown and yellow, then add dots and marks in lighter and darker shades to add interest.

To create evil eyes, make the white of the eye red or orange, with the iris a bright yellow and a tiny dark dot for the pupil.

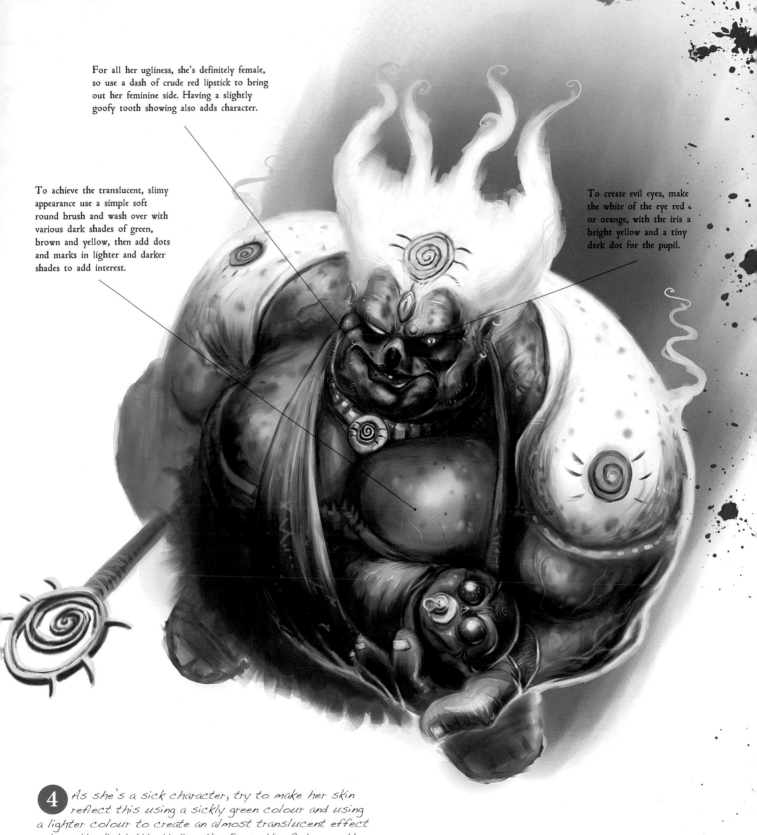

4 As she's a sick character, try to make her skin reflect this using a sickly green colour and using a lighter colour to create an almost translucent effect where the light hits it directly. Erase the flat grey, then add the shadows to the background to show off her hair and to give it some contrast.

mutant warrior

Gelgashprid Mangleclaw

Gelgashprid was born in The Burninglands and straight away appeared very different physically from other orcs, or any other goblinoid. Born with one arm fused to his chest, the other arm a massive crab-like claw, with various green bubbles and tentacles randomly scattered over his body, he is a fearsome and disgusting sight to behold.

As is the orc tribal way, he was often beaten and punished for looking different until one day, when one of the larger orcs was beating him, Gelgashprid had a rush of anger. He reached out with his clawed arm, grabbing and crushing the other orc's leg easily. The orc screamed out in agony while his now useless leg flopped beneath him and Gelgashprid's clawed arm came rushing up for his neck … his head popped off easily.

Gelgashprid is now a leading warrior in the tribe and not one orc has ever thought about beating him since.

2 Decide where you want the light source to come from and indicate this with an arrow. Develop the sketch adding more definition to his face and clawed arm as that's where the main focus will be.

1 To focus the viewer's attention on Gelgashprid's upper body and his massive claw, choose a downward angle of view and block in some strong shapes. Don't worry too much about his legs - from this angle they can be painted receding into the background.

3 Wash in a grey background and then start shading the entire figure with a dark brown oil pastel brush, using the arrow as a reference for the lighting. The harder you press with the brush the darker the paint becomes, so use it softly for where the light hits directly and press harder for the shadow areas.

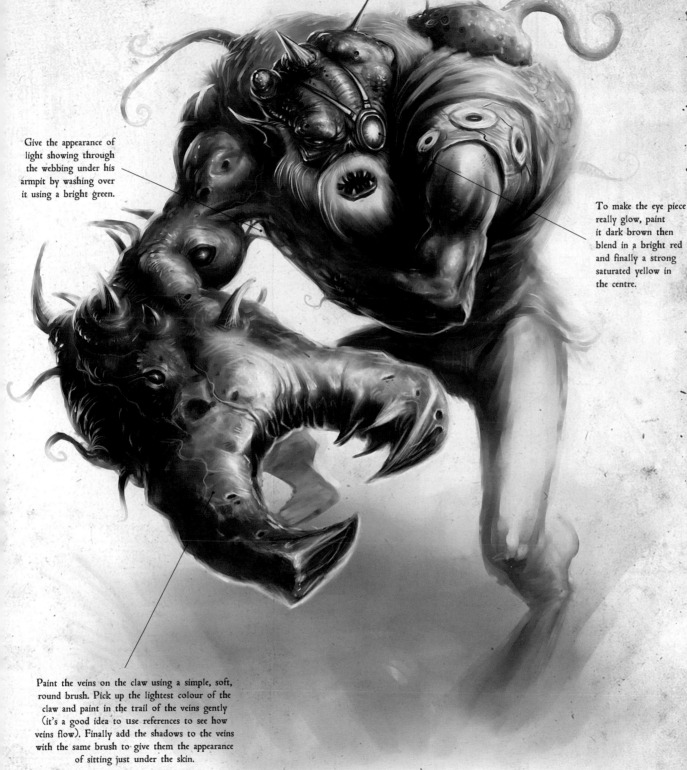

Give the appearance of light showing through the webbing under his armpit by washing over it using a bright green.

To make the eye piece really glow, paint it dark brown then blend in a bright red and finally a strong saturated yellow in the centre.

Paint the veins on the claw using a simple, soft, round brush. Pick up the lightest colour of the claw and paint in the trail of the veins gently (it's a good idea to use references to see how veins flow). Finally add the shadows to the veins with the same brush to give them the appearance of sitting just under the skin.

4 Wash over his flesh with a nice warm colour and make the background a pale grey-green so that his legs fade out, as you don't want these to be the focus. When painting in all the details, be sure to add lots of visual interest with lumps, bumps and holes in his flesh. Use rim light around the claw to really lift it off the background.

demon summoner

Bringel Majeeksplattah

Bringel's talents as a demon summoner are well known but his trouble controlling the demons is also renowned and feared throughout the land.

 More often than not he will summon mighty demonic creatures to do his bidding and totally lose control of them, but finally, after many close shaves, he has managed to turn this to his benefit. If there is to be a raid on a human settlement his chief will send forth hundreds of orc warriors while Bringel summons his demons. Then Bringel will lose control and the demons will rampage through those very orcs and on to the human settlement, doing more damage to the humans than the orcs can possibly do on their own. Obviously they lose hundreds of orcs in the process but that's a small price to pay to see the puny humans crushed.

2 Develop the sketch by drawing Bringel's robes billowing out from the blast of the summoning, all tattered and frayed. Don't draw his legs in, as the glow from the demon and summoning ring will wash that part of his body out.

1 Show Bringel snapping a magical staff, releasing supernatural light and energy with his demon below him in a summoning circle. Draw him leaning backwards, with the viewer looking up at him, and with the angle slightly tilted for extra drama.

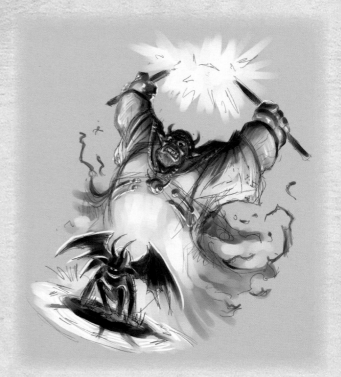

3 Fill in the background with a neutral grey and add the dark and light tones gradually. The two brightest light sources will come from the summoning circle and the cracking of the staff so make these the brightest areas and make Bringel's head and the demon the darkest parts of the painting.

The up-lighting hitting Bringel's face needs to be picked up by his orcish features – his large brow, prominent jaw and high cheek bones. Using the bright yellow emanating from the demon, blend this in using an opaque oil pastel brush. For any pinpricks of highlight, such as his fang and warts, use the same colour but with a pencil, which will lay down the colour exactly, without any blending.

Include crackles of energy swirling up and around the summoning circle and demon, which rise up and glow, washing out Bringel's lower body.

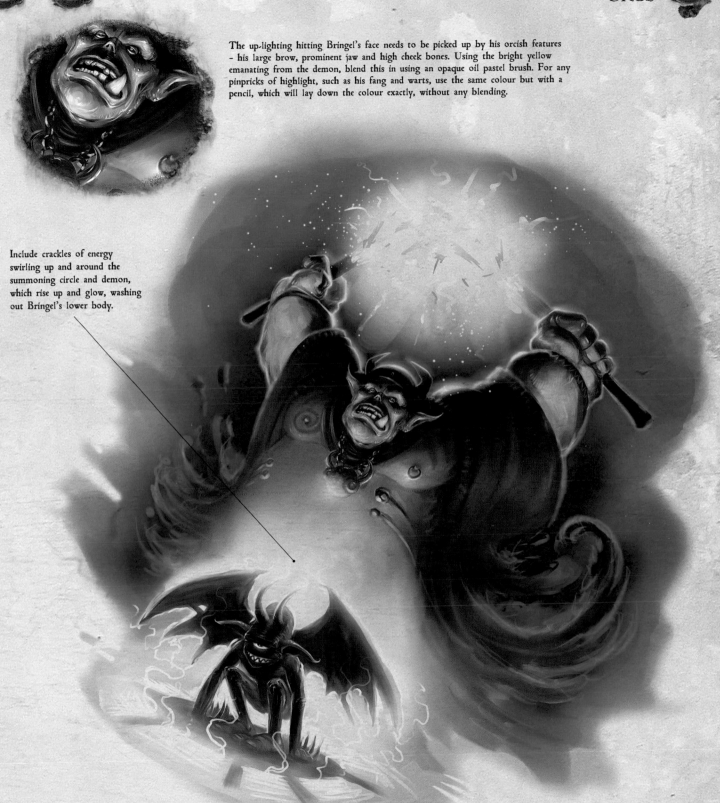

4 Use a green/blue colour for the background to stand out against the red of his robes. Paint in the rim light from the blast of the broken summoning staff so that Bringel stands out. Add to the excitement and energy of the image by using the light from the summoning circle to throw up dramatic shadows on Bringel's face. For the final details, give Bringel a piercing and some body paint and refine his face.

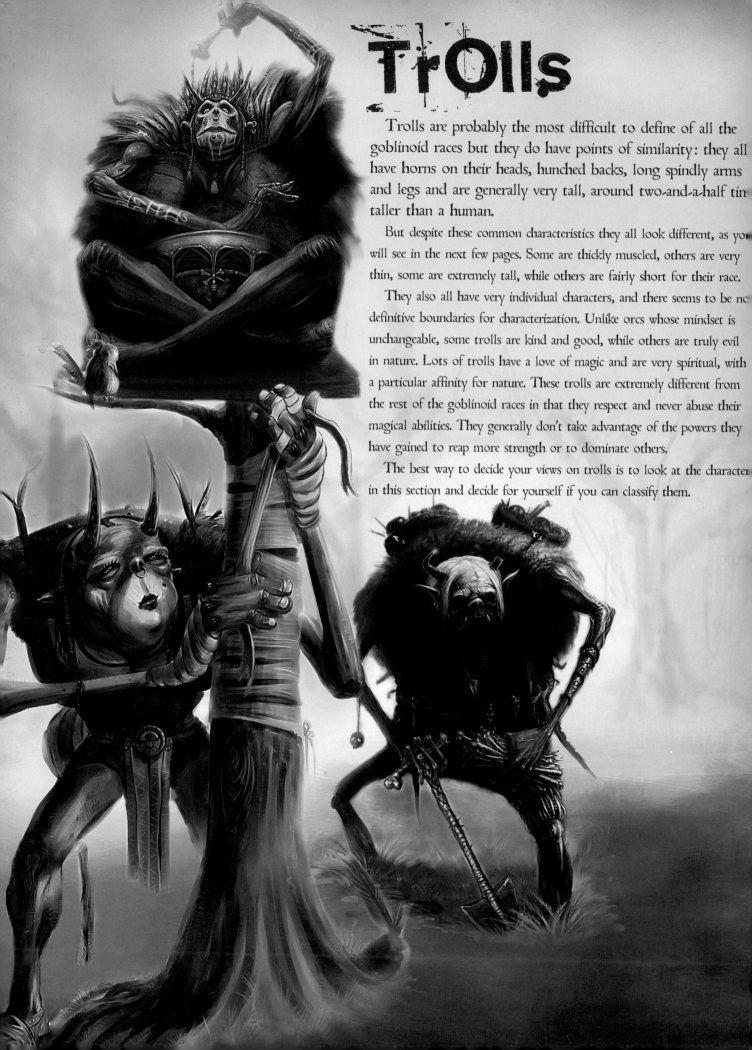

TrOlls

Trolls are probably the most difficult to define of all the goblinoid races but they do have points of similarity: they all have horns on their heads, hunched backs, long spindly arms and legs and are generally very tall, around two-and-a-half tin taller than a human.

But despite these common characteristics they all look different, as yo will see in the next few pages. Some are thickly muscled, others are very thin, some are extremely tall, while others are fairly short for their race.

They also all have very individual characters, and there seems to be no definitive boundaries for characterization. Unlike orcs whose mindset is unchangeable, some trolls are kind and good, while others are truly evil in nature. Lots of trolls have a love of magic and are very spiritual, with a particular affinity for nature. These trolls are extremely different from the rest of the goblinoid races in that they respect and never abuse their magical abilities. They generally don't take advantage of the powers they have gained to reap more strength or to dominate others.

The best way to decide your views on trolls is to look at the character in this section and decide for yourself if you can classify them.

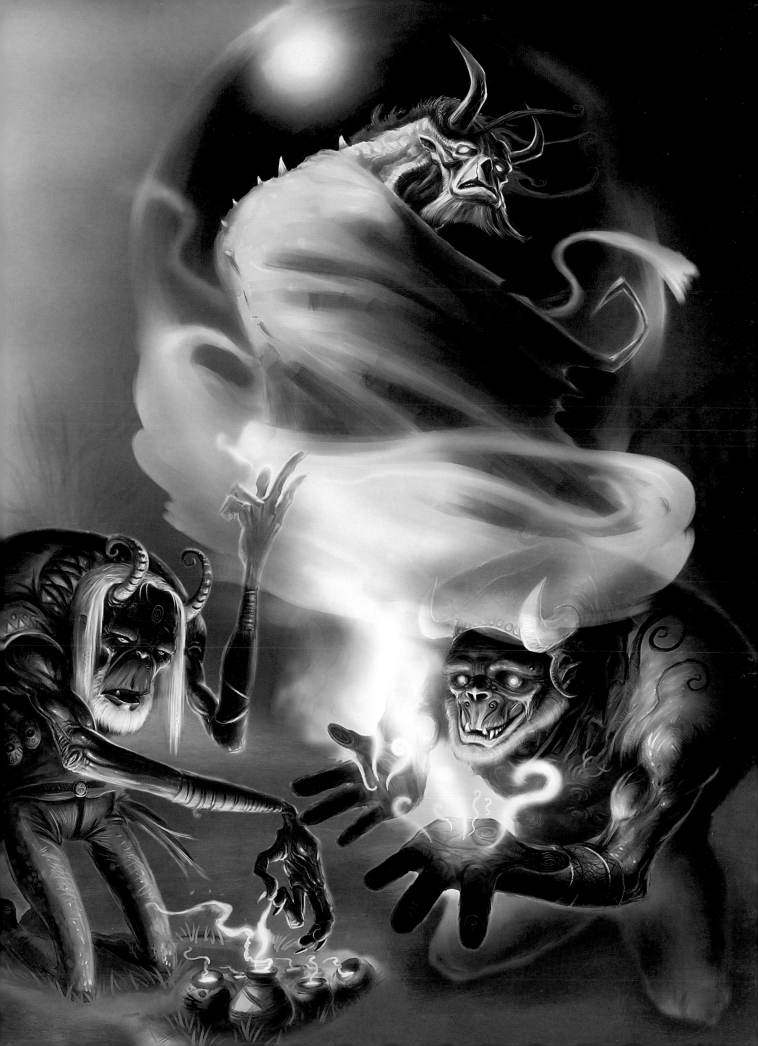

shaman

Widemouth Feathernest

Widemouth's shamanic powers are exceptional. She is able to heal, summon animal spirits and commune with the environment by putting herself into a trance using a complicated mix of drumbeats. She decorates herself only with things that nature can provide, including feathers, fur and hide, organic pigments and bone jewellery.

She is peaceful in character, happy living in her cave on the highest mountain peak, beating her drum and befriending animals and plants. She loves the tranquility of living alone and every morning watches the sun rise over the beautiful scenery below and starts her daily drumbeat to the rhythm of nature. Beware if you disturb her though, as apparently she is no longer a vegetarian.

2 Draw in her face and refine a few decorations, making sure that you get the crossed legs as correct as possible. Draw some additional little squiggles here and there to indicate the details, such as the necklace – these will be refined later.

1 Widemouth spends a lot of time in a trance so depict her beating her drum and staring upwards. Create a worm's eye view of her sitting cross-legged around her drum waving her drumstick/bone about.

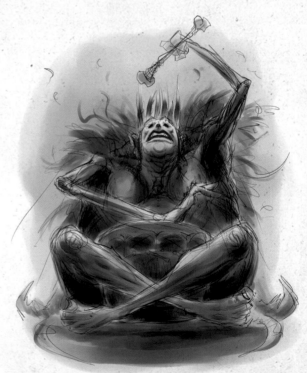

3 Flip the image to make sure the balance of her anatomy is working. If it seems OK, carry on with washing in the green tones. Flipping the image, or, if you're drawing on paper, looking at it in the mirror, can help you spot any compositional imbalances that can then be fixed.

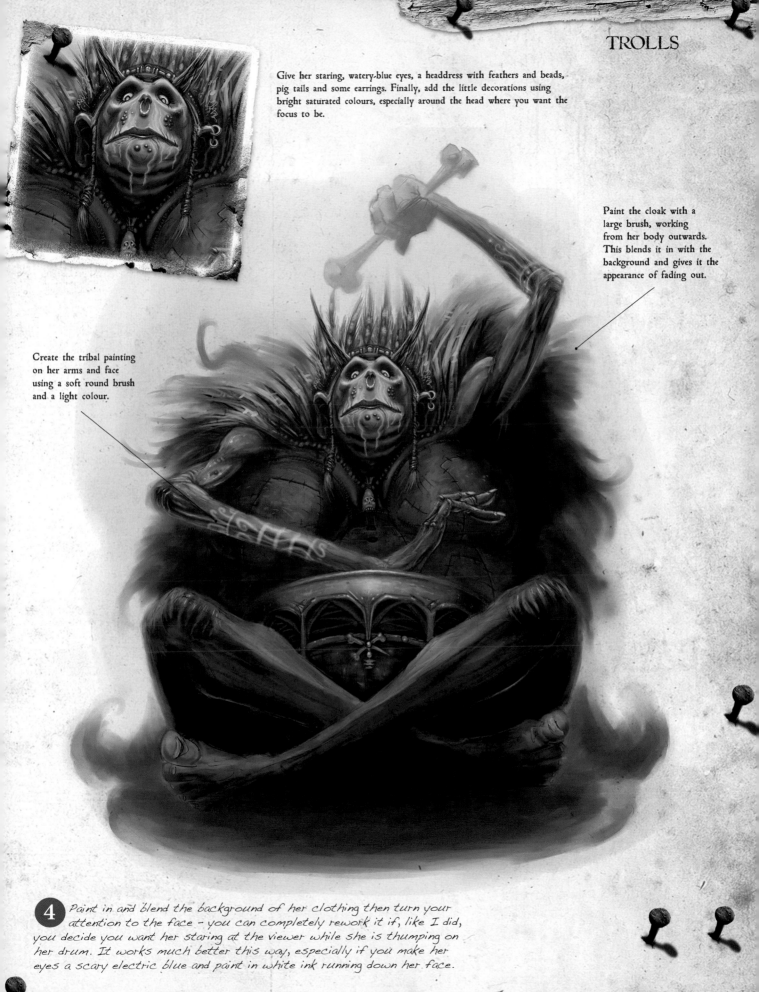

Give her staring, watery-blue eyes, a headdress with feathers and beads, pig tails and some earrings. Finally, add the little decorations using bright saturated colours, especially around the head where you want the focus to be.

Paint the cloak with a large brush, working from her body outwards. This blends it in with the background and gives it the appearance of fading out.

Create the tribal painting on her arms and face using a soft round brush and a light colour.

4 Paint in and blend the background of her clothing then turn your attention to the face - you can completely rework it if, like I did, you decide you want her staring at the viewer while she is thumping on her drum. It works much better this way, especially if you make her eyes a scary electric blue and paint in white ink running down her face.

potion brewer

Urgle Slippypotte

Urgle has a talent for brewing potions and poisons of all kind. He uses many interesting ingredients, from beetle brains to ogre skin and from pickled frogs toes to the stem of the venomous Mangleleaf plant. He usually mixes and matches but always produces something 'useful' to his clients.

He has limited magic that flows from his fingertips and he uses this as the last ingredient to give his potions their full potential. Although he doesn't use his concoctions himself, he does openly ply his wares in the Freedom Bridge area, happy to 'sell' them to the highest bidder: whoever can supply him with the most human brains to eat. To him they're like oysters … and the more slippery and wet, the better!

1 Urgle's fondness for brains means that he's always collecting ingredients and making potions so that he can acquire his next meal. An image of him making his potions will be the most interesting. Draw his hand raised up, to which you can give a flicker of magical light while he's sprinkling some ingredients into a pot.

Choose a forest green for his clothing, with a slight variation in colour and tone to distinguish his top from his trousers and so that it doesn't look boring. Use a reddish-brown skin tone to complement this.

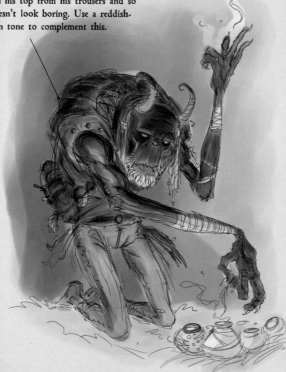

2 Loosely draw in the shimmer of magic, his bags and pots and general details. Give him a beard and a large forehead to add to his troll character.

3 Wash in a grey background and start to add some colour to his clothes and flesh. Think carefully about where your major light sources will be (the flicker of magic and the sprinkle in the pot in this case) and block in the shadows and highlights accordingly.

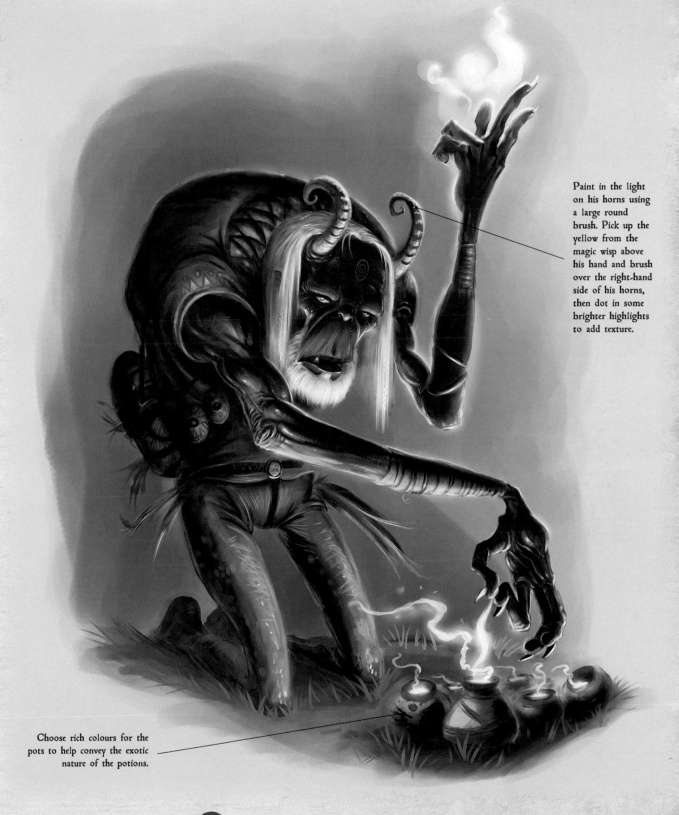

Paint in the light on his horns using a large round brush. Pick up the yellow from the magic wisp above his hand and brush over the right-hand side of his horns, then dot in some brighter highlights to add texture.

Choose rich colours for the pots to help convey the exotic nature of the potions.

4 Once you have painted in Urgle and are satisfied with the results, the final stage is to make sure the reflection of light is clear, especially on his horns and hands.

bone collector

Morbus Marrowmuncher

Morbus is a very strange creature, even for a troll. You might spot him standing on a distant hill watching a great battle ensuing far below. Up there he watches the action with his black eyes, standing completely still with only his limp, straw-like hair moving in the breeze. He will still be standing there days after the battle has finished, until something in him signals him to move. He then thuds down the hill towards the hundreds or sometimes thousands of dead soldiers strewn across the battlefield.

When he arrives at the scene, he picks through the bodies and sucks the marrow from the best of them. He collects masses of bones and skulls to make strange models and decorations for his home and clothing.

He has never threatened a single living soul, as far as anybody knows, so they leave him well alone and allow him to clear up the mess from battles – after all, it saves them a job.

1 Aim for a menacing feel in your image and try out a completely different painting process as an experiment for yourself. First, lay down a pinkish texture, as painting on pure white can be uncomfortable and having a wash of colour to paint on can help you start up. Now paint directly on to the pink with broad brushstrokes, shaping the figure with colours and tones.

2 Erase the pinkish background to create a frame that Morbus's body parts can break out of to add interest. Work with large brush marks at first, painting in his legs and a little foliage, then start to include details like bones and skulls. Refine his hands with smaller brushes.

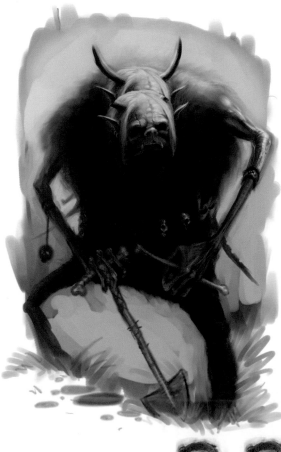

3 Looking at the rough drawing you can see that his head is too high up on his body; the other trolls' heads almost come out of their chests because they're hunched over so much. In Photoshop, use the Lasso tool around his head, and copy and paste it lower down. Paint in his shovel – this is a key prop as he has lots of digging to do.

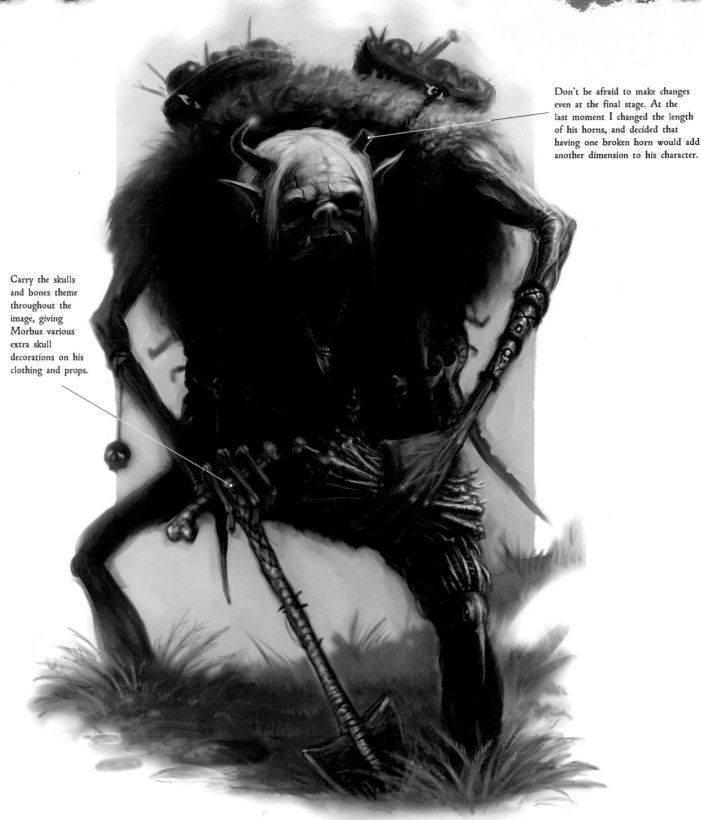

Don't be afraid to make changes even at the final stage. At the last moment I changed the length of his horns, and decided that having one broken horn would add another dimension to his character.

Carry the skulls and bones theme throughout the image, giving Morbus various extra skull decorations on his clothing and props.

4 When you are happy with his pose, start to add all the little details; lots of bones in his hand, textures on his shovel, baskets packed with skulls on his back and so on. The final stage is to warm up the colour slightly to a much deeper shade of red, which will help separate Morbus from the background and really adds to the mood of the piece.

myst hunter

Dendra Nightmyst

Dendra hunts in the night, stalking his prey and confusing them by summoning a misty smoke and swamping them in it. He then silently launches on them and tears them apart. It is surprising how fast he can move considering his bulk. He is massive for a troll and muscled like an ogre, making some wonder whether he was an experiment in magic gone awry.

During the day he sleeps in a cave in Caramor Forest. His home is littered with bones and decaying flesh but he seems totally happy there. His favourite meal is humans. He'll quite happily chew on their bones and suck the marrow out all night long. When times are hard he'll even eat goblins, although he dislikes the bitter taste of their green flesh.

1 As Dendra is such a massive size, even for a troll, use a worm's eye view of him to emphasize this to the full. Ensure the viewer is looking up at him, focusing on his head and thick neck, while his lower half is surrounded by the mist he controls. This means there is no need to worry about the lower portion of his body at all.

2 Indicate the light direction that you want with an arrow and rough in a moon-like shape around and behind his grim face. Make his cloak tatty and draw in a squiggle for what will be the mist.

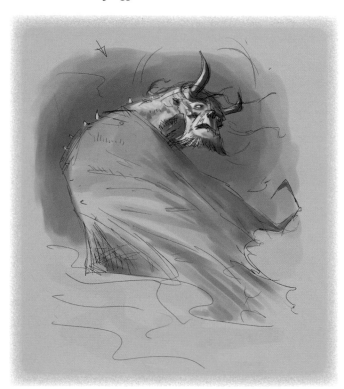

3 Lay in a flat grey background and then start washing in basic tones. As it is a night-time image, take into consideration that the final painting needs to be quite monotone while you work in these initial washes, so concentrate on creating lighter and darker areas rather than adding too much colour.

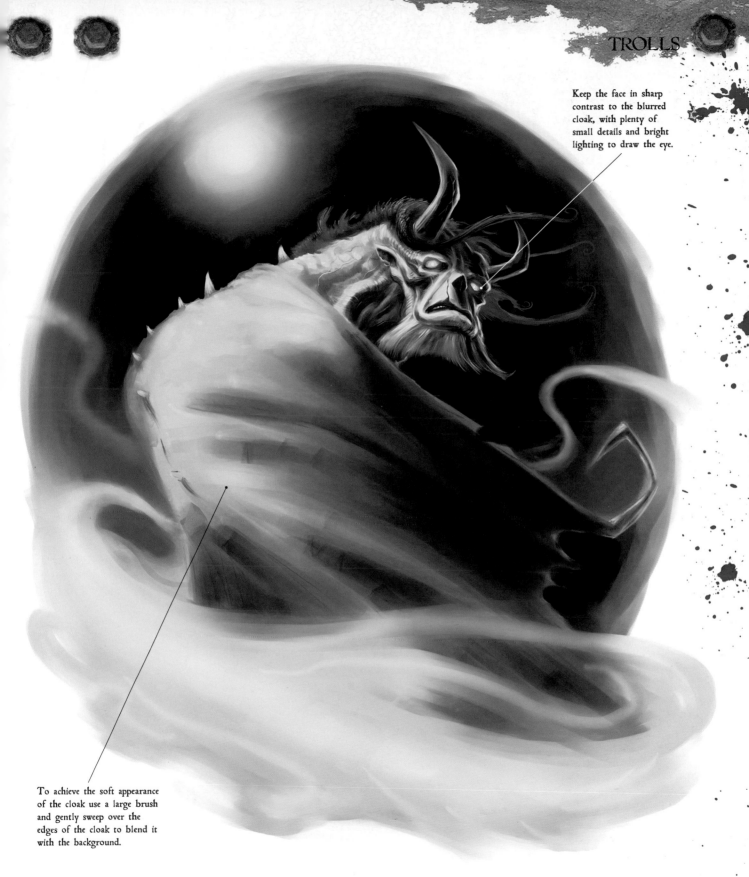

Keep the face in sharp contrast to the blurred cloak, with plenty of small details and bright lighting to draw the eye.

To achieve the soft appearance of the cloak use a large brush and gently sweep over the edges of the cloak to blend it with the background.

4 Erase the grey background to leave an oval vignette then deepen the sky to a midnight blue, with a hint of misty moon to his left. Use very broad strokes to define his cloak and the mist, while making sure more detail and contrast are applied to his head. Add the glowing eyes using a large soft brush, doing several sweeps until they glow just right.

tree tender

Olive Treebranch

Olive cares for her forest home – she cares so much for the trees and plants that she actively tries to heal them from disease and injury. She has created a marvellous organic 'salve' that she soaks into cloth bandages and wraps around sick trees. Within days, if left alone, the tree will remarkably spring back into full health, leaving a lovely smile on Olive's little cherry lips.

She is very shy and steers clear of any humanoids if she can help it, including those of her own race whom she mistrusts deeply. So she lives her days out peacefully enjoying the four seasons and caring for her little patch of Eden.

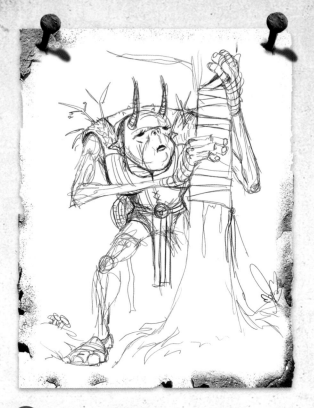

2 Sketch in some details including the branches on her clothing, and the bandages wrapped around her fingers. It would be nice to give her some 'hippy' hair braids, so give a quick indication of these with some squiggles down the hair strands.

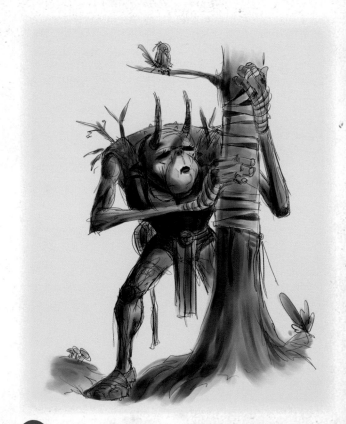

1 Olive loves trees, so it makes sense to depict her hugging and healing a tree to really express this side of her character.

3 Wash in a grey background and then go straight into washing in some colour choices. Give her skin a nice soft green, almost a 'grass green' colour. Sketch in and loosely colour a bird on the branch.

To achieve the soft brush marks on Olive's face use an oil pastel brush to gently add the shadows. Then bring out the highlights and sharp details with a pencil. Draw in the eyelashes solidly using a dark brown colour picked up from the tree and add a bright yellow dot of highlight in each eye.

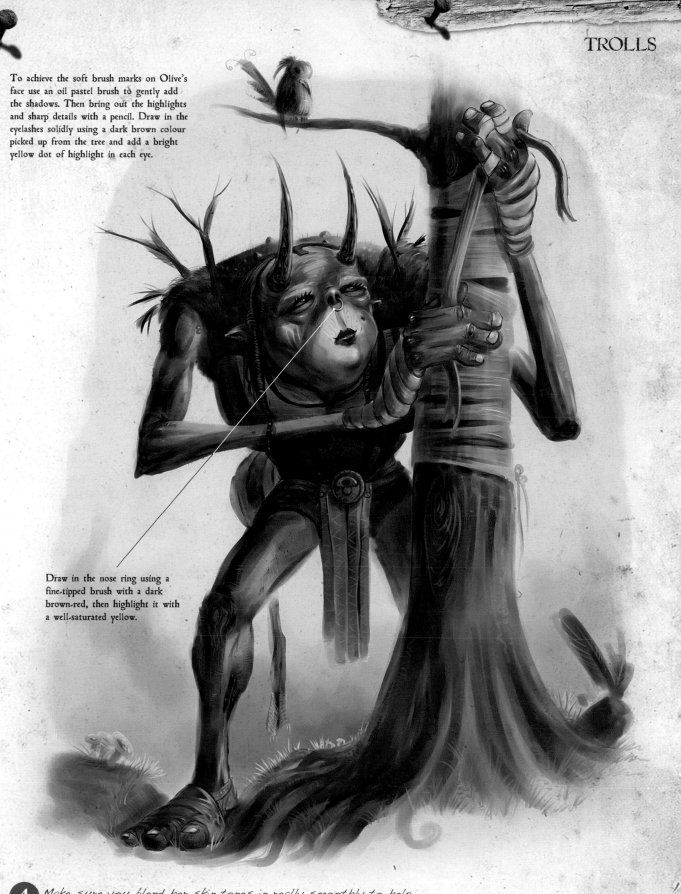

Draw in the nose ring using a fine-tipped brush with a dark brown-red, then highlight it with a well-saturated yellow.

4 Make sure you blend her skin tones in really smoothly to help reflect her soft nature. Paint her hair in a reddish orange colour and use a bright cherry red for her lips. Paint in the shadow of her horn running across her face to indicate the light source and make sure the bird looks peaceful perched on the branch, to show that Olive is no threat at all.

Spirit keeper

Ethril Steelkepe

Ethril is another of the rare troll souls who is kind and gentle. He has no malice or intention to hurt anyone or anything. Ethril's raison d'être is to find lost souls and to care and look after them until they can travel to the next plane of existence. This comes at a price for him. His fingers are slowly blackening and dying and he knows that eventually this affliction will carry him into the spirit world too. But he is actually quite happy about this.

He dreams of travelling to worlds unknown, of rekindling friendships with spirits that he has cared for, and of meeting new spirits that can teach him many things. Life is a constant dream and fascination to him.

2 Start to sketch in more details, such as his facial expression, musculature and costume. As the spirits are so key to this character, give them some kind of physical form by shaping them as twirls and curls.

1 As Ethril is a dreamy character, wistfully thinking of future possibilities, depict him staring into the light of the spirits he is helping. To be able to show that his fingers and hands are blackening, you need to place them in a prominent position in the drawing. Position Ethril leaning forward and kneeling while staring at the spirits.

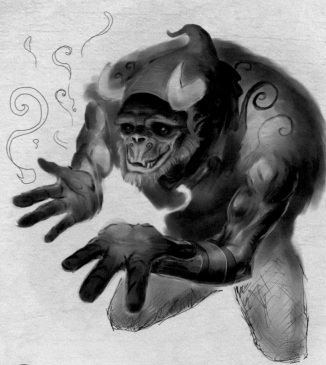

3 Now jump straight into the painting, blending in the colours as you go, slowly blackening his fingers and working up the shadows around his shoulders and side. Don't put any detail into his legs as these will fade out into the distance, in order to keep the focus on his hands and face.

Use a soft round brush to achieve the dreamy lighting coming from the spirits and reflected on to his face.

Paint in a loose wash of colour in the background that gradually fades out to leave an appealing vignette.

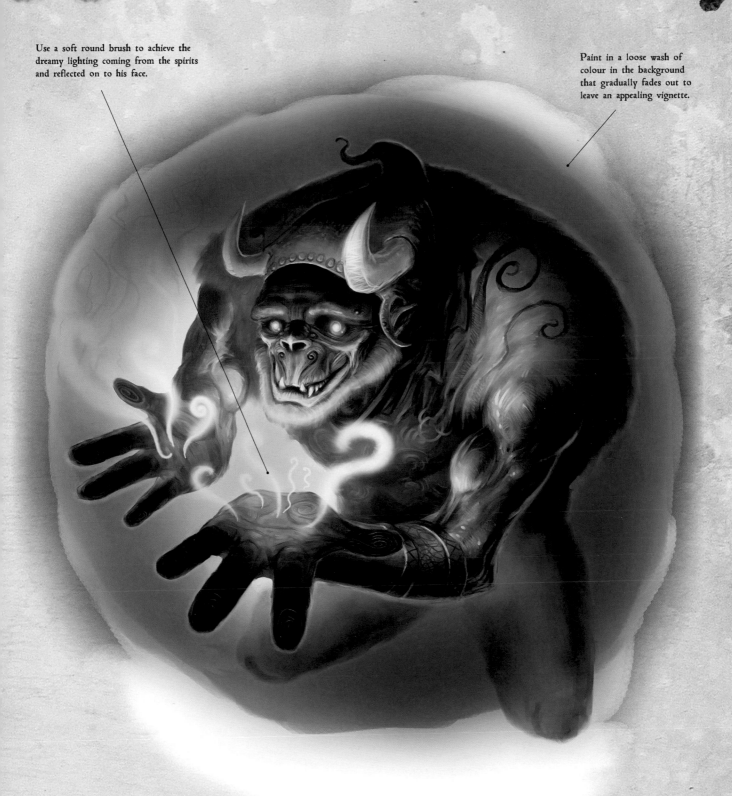

4 Darken the background as if Ethril is in a dark room and the only bright light emanates from the spirits in his hands. Paint in a slight rim light on his shoulders and back to separate him from the background. Blacken his fingers more and add swirls and wrinkles to his fingertips. Finally, create a warm yellow glow in his eyes with a soft brush.

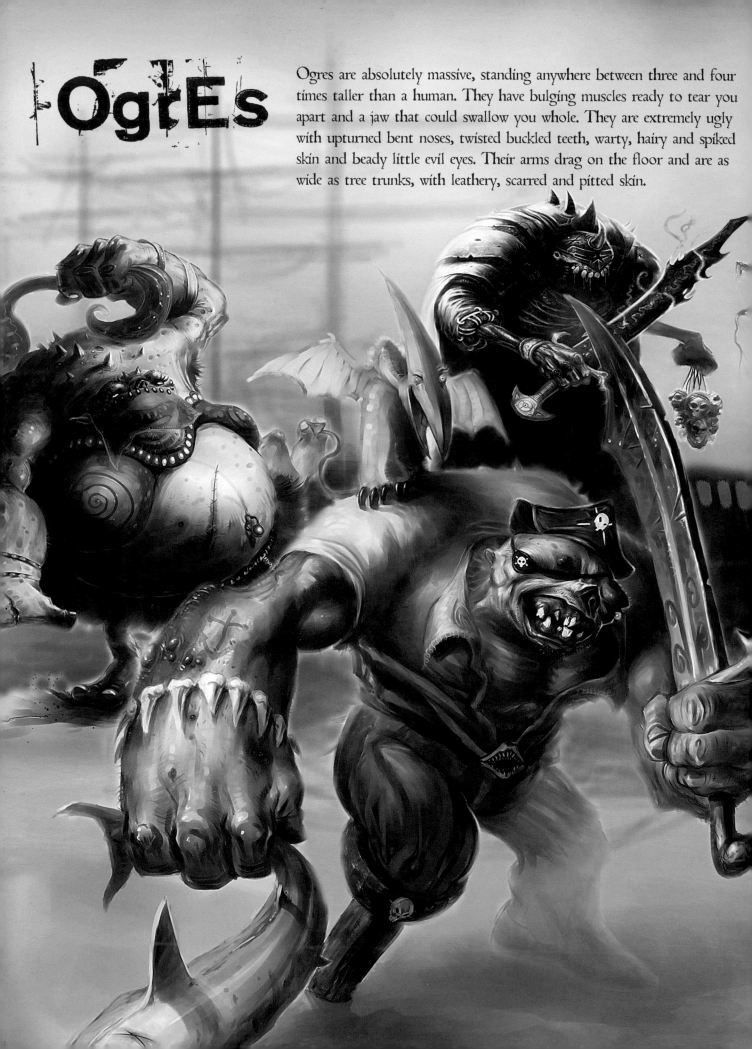

OgrEs

Ogres are absolutely massive, standing anywhere between three and four times taller than a human. They have bulging muscles ready to tear you apart and a jaw that could swallow you whole. They are extremely ugly with upturned bent noses, twisted buckled teeth, warty, hairy and spiked skin and beady little evil eyes. Their arms drag on the floor and are as wide as tree trunks, with leathery, scarred and pitted skin.

They have stubby little legs with huge two-toed feet and lumber along snorting and drooling, leaving huge footprints wherever they go, so it is not hard to track them.

If you thought orcs smelled bad then you've never met an ogre. There is not a description for the stench that wafts off these creatures. You can almost see the smell rising as a vapour from their grey/green/brown bodies.

Ogres are extremely stupid; it is unlikely that they would actually survive as a race if they did not have a weird, almost symbiotic, relationship with the orcs. The orcs bribe the ogres with massive sparkling gems and jewels (which ogres seem to love) to fight for them in their raids against the human settlements. Orcs allow the ogres free rein in their encampments to 'play with' (crush) the goblins and hobgoblins.

Ogres are used as massive tanks in the orcs' battles. They can take a huge amount of damage to their bodies before they fall and more often than not, if they've taken lots of arrow hits, they're already dead but their slow brains haven't sent the signal out. This means they can effectively fight for a while before dropping like a stone, crushing anything beneath them.

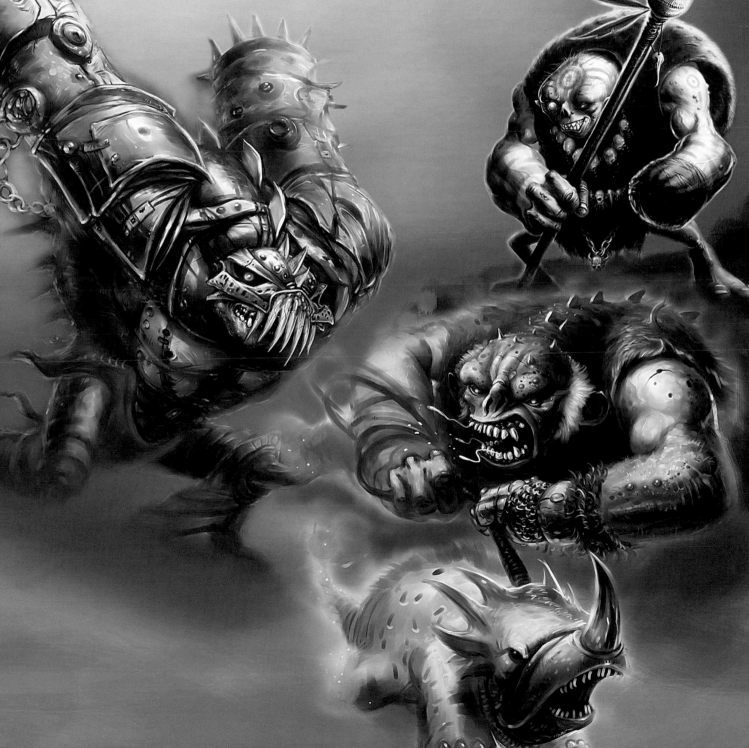

metal slugger

Crushtank Hammerfist

Crushtank likes to smash things. He doesn't care where or what he smashes, as long as he's allowed to beat his chest and charge at something living with the intention of killing it.

He's a raging, insane beast on the battlefield. He quite often slaughters his own troops as he flies into a war frenzy, swinging his mighty iron fists around.

Unbelievably large and angry for an ogre, Crushtank towers above the biggest of his kind. When not at war he is chained up and fed on goblins. It takes six fully grown ogre warriors to hold him down. They wheel him out on to the battlefield at least once a week for some light exercise, where he smashes and crushes all in his path.

When the battle is won, they feed him the bodies of the dead enemies to cajole him to sit down, then jump him and chain him up again. And so the cycle repeats itself.

2 As you develop the sketch, refine his armour so that he is almost completely covered in it, with only his lower jaw partially showing. Give him one beady eye looking through the slit in his helmet.

1 Crushtank is an exciting character to draw, so try to create a dramatic pose. After drawing the egg shape for his body, make sure his head is lunging forwards with his thick arms swinging behind him and his legs bent. Draw the whole image on a tilt to add to the drama.

3 Wash in the brown tones to establish the lighting and to add some texture to his armour. This gives you a base to paint the background and armour colours over in the next step.

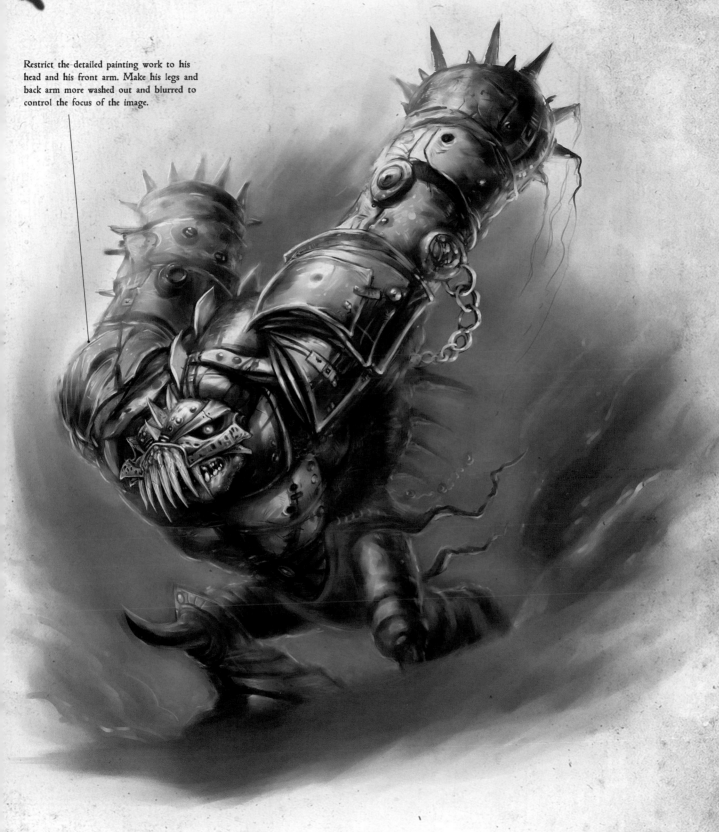

Restrict the detailed painting work to his head and his front arm. Make his legs and back arm more washed out and blurred to control the focus of the image.

4 Paint the background in a strong orange colour, which helps to emphasize his inherent rage, and use hints of the background colour reflecting off his armour. Work up the detail selectively to keep the main focus on his face and front arm. Add some rocks to the background with slight highlights to increase the perspective in the image.

Seer

Gorgar Stumpfist

Gorgar is totally insane, even by ogre standards. Born blind in one eye, he discovered he could predict future events if he concentrated on 'seeing' through his blind eye. His first ever vision was of himself standing alone on a cliff top, lightning crackling through the air and hail pouring down about him. He saw himself hacking off one of his hands and throwing it off the cliff face with a roar while the lightning silhouetted him against the bright flash of nature's fury.

After many correct visions his tribe made him the seer and his standing has never faltered. His final prediction saw him die at the hands of the orc priestess Orgrog (see pages 88–89), stabbed in the back, eyes hacked out and thrown off the very cliff top where his visions had started.

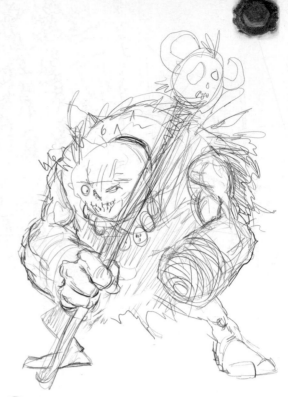

2 Work up the details in pencil, creating some texture and interest in his clothing. Rough in some skulls hanging around his neck and draw some bandages around his stump.

1 Gorgar is an odd creature so reflect this by giving him a quirky looking staff with an strange skull-like head. Make one of the eye sockets on the skull larger than the other to echo Gorgar's eyes. He's an animated, edgy guy so draw him leaning to one side as if he might skip from foot to foot while shaking his staff and grinning insanely.

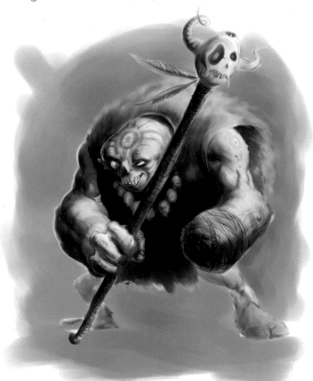

3 Wash in a quick grey background and paint in the brown for his fur clothing. Give his bandages a dirty green/brown/grey colour as if they have never been changed – ogres are dirty creatures by nature. As he is a seer give him some body paint/tattoos/markings by washing in some simple shapes over his arms and the top of his head.

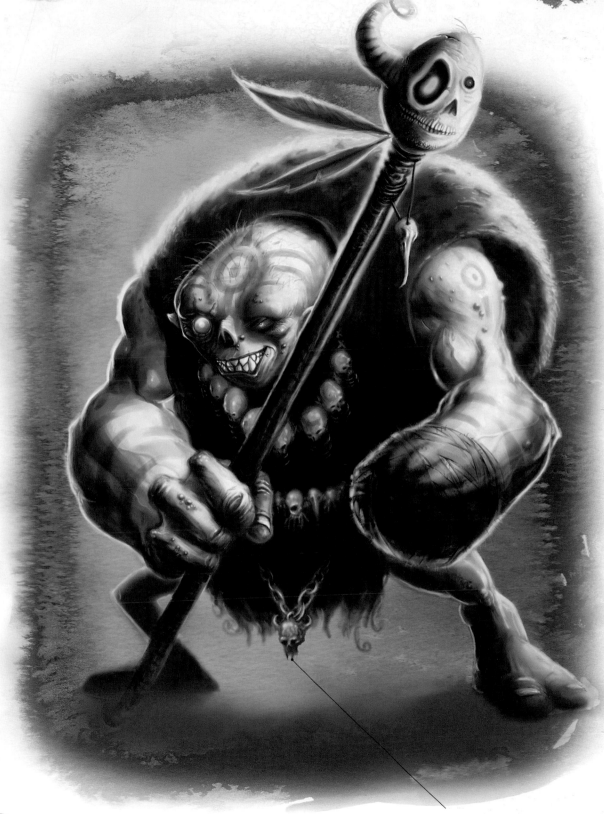

4 Continue to work up the details until you are satisfied. Make the blind eye more obvious by bulging it out more prominently. Refine the skull on his staff to make it into a comical replica of his own face. Finally, add a watercolour wash texture to the background to frame him.

Adding the hanging skull on a chain creates a triangle shape up to his shoulders. Similarly, an inverted triangle is formed in the space between his feet and his head. These clean compositional lines, reinforced by the strong diagonal of the staff, give him a solid, grounded feel.

undead warrior

Orgrod Darkblade

Orgrod is an outcast from his tribe. He is weak and frequently beaten. He eventually ran away from the tribal land of Ogrock to a far-off place and found a cave to settle in.

On his first night in the cave he dreamed a voice was begging him to dig; promising him a huge reward if only he would rescue it. When he awoke, he scrambled to the back of the cave and started digging. He dug for days while the voice continually begged him to release it.

Finally, he broke through to another chamber and found a large sword, glinting with unearthly forces. He grasped the hilt and dragged the sword out with the last of his energy. All night the sword's voice promised him power beyond his wildest dreams if he gave his life in return. Orgrod offered it willingly and awoke to find his body in an undead state, rotted and stinking (worse than usual), with his flesh hanging off his bones. But with his new powers, revenge on the tribe would be his! So Orgrod is slowly and silently making his way through fissures and cracks in the Undercrush Tunnels that the sword has told him about, nudging his way to Ogrock for revenge.

2 Work up the sketch giving more prominence to the ties holding his jaw on to his skull. Craft the shape of the sword to make it look very otherworldly and think about the construction of his plated armour.

1 Depict Orgrod holding his sword out and grasping a tied bunch of skulls with his other hand. Consider having his jawbone loose but tied to his skull and sketch in a few lines to indicate this. In the final image his lower body will fade out into mist or smoke so there is no need to block this in.

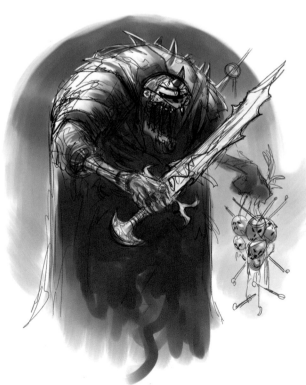

3 Wash in the initial tones, so that the light is coming from above him and slightly from the left. Leave the colouring on the sword until the final stage, as it needs to have a life, energy and light of its own.

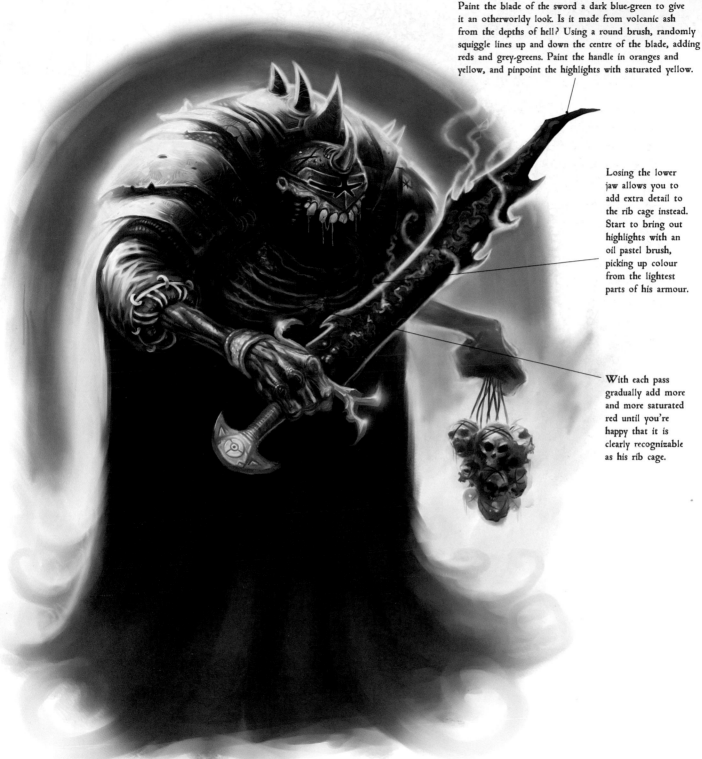

Paint the blade of the sword a dark blue-green to give it an otherworldy look. Is it made from volcanic ash from the depths of hell? Using a round brush, randomly squiggle lines up and down the centre of the blade, adding reds and grey-greens. Paint the handle in oranges and yellow, and pinpoint the highlights with saturated yellow.

Losing the lower jaw allows you to add extra detail to the rib cage instead. Start to bring out highlights with an oil pastel brush, picking up colour from the lightest parts of his armour.

With each pass gradually add more and more saturated red until you're happy that it is clearly recognizable as his rib cage.

4 With another wash of colour make the background a blue/green night shade, with a pale blue light, perhaps moonlight, reflecting off his armour. Give his armour a brown/reddish grey quality to make it look slightly old and add to that idea by painting cracks and dents all over it. I decided to remove his bottom jaw altogether and instead show a hint of his neck bone, along with his rib cage with blood and flesh hanging off it. His sword is a dark mystical weapon, so give it a weird patterned texture and smoky, spooky glow to make it look unearthly.

belly dancer
Grundel Bumperdunce

In the eyes of ogres, Grundel is one hell of a beauty! She has mastered the art of jiggling her belly so that the ground beneath her feet shakes and a sound like the rumbling of distant thunder fills the sky.

She is the most lusted-over female in all the ogre lands but being a belly dancer she must not, by tradition, be touched. Secretly she's very glad of this because she gets to wear the most glamorous of clothing and jewels that other female ogres can only dream of.

Don't let her dancing blind you to the fact that she is also a warrior of her tribe and will not hesitate to decapitate you if you insult her … or just happen to be a dwarf.

2 Refine her face a little more, but leave the fine nuances until the painting stage. Look at references of belly dancers' costumes and begin to work this in, remembering to keep the feel suitably grubby. Female ogres have the same massive bulk as the males, with big wide hands, oddly small and skinny legs, and, of course, Grundel has an extra large belly!

1 Grundel should definitely be dancing. Whether we'd call it dancing is another thing but depict her with one leg in the air, jumping up and down and wiggling her belly. Give her an almost delirious facial expression which will be visible behind a yashmak-type veil.

3 Wash over with a grey/brown to get the tones in place and to show the light direction. Here the lighting is hitting Grundel from the right-hand side and slightly above, so the shadows need to fall on the opposite side of her body, to the left.

Wash in the purple colour of the veil using an oil pastel brush, then use the same brush to gently highlight around the mouth and teeth, giving the effect of translucent fabric.

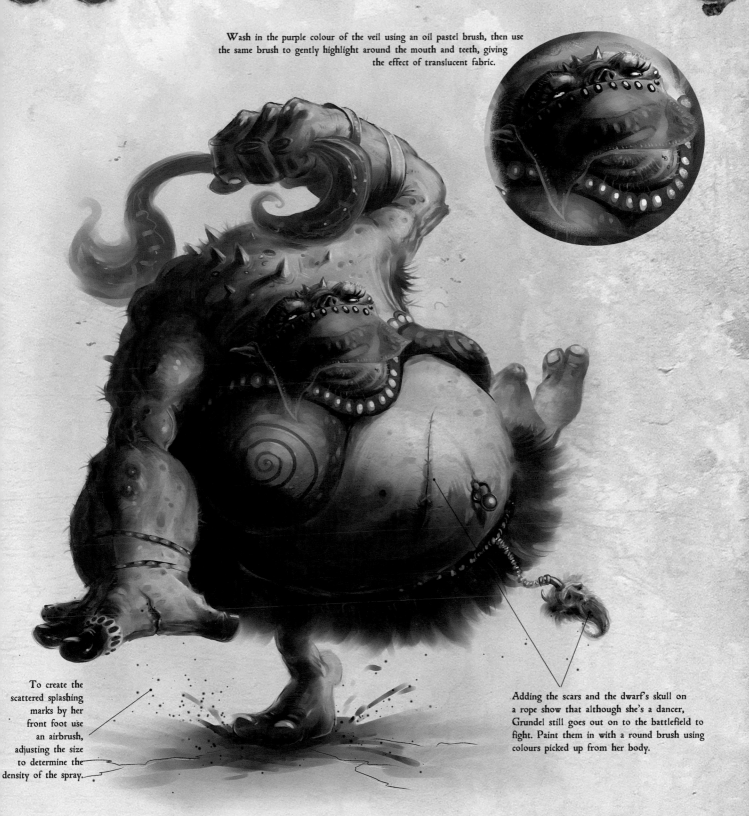

To create the scattered splashing marks by her front foot use an airbrush, adjusting the size to determine the density of the spray.

Adding the scars and the dwarf's skull on a rope show that although she's a dancer, Grundel still goes out on to the battlefield to fight. Paint them in with a round brush using colours picked up from her body.

4 Paint her face in, giving her boss-eyes and an open mouth revealing gaps between her greying teeth. Give her some unsightly armpit hair and some flies to indicate the whiff she is giving off. Spend some time painting in the highlights on her costume which will help draw the eye across the image. As a final touch, add a belly piercing and a poor dwarf's head on a hook tied to her belt while she jiggles her stuff!

pirate

Clodhopper Nobeard

Clodhopper wanted to see the sea, he wanted to see it so much that once he saw it he ran in up to his neck and nearly drowned. If it wasn't for a band of untrustworthy, slimy pirates dragging him from the depths in a net, he would probably be dead.

Although their ship was listing badly, they decided that they could use Clodhopper as bait for ships. Their plan was for the naval ships to spot their seemingly sinking ship, fool them into getting close up alongside, then unleash Clodhopper on them. Unfortunately for Clodhopper he lost his leg to a cannonball on his very first outing. Not that it worried him, for after they raided and sunk the naval ship they sewed him up, made him his very own peg-leg and he beamed with joy.

Now the Agein Sea is forever unsafe as Clodhopper jumps on to ships with the aid of his pet pterodactyl Nibbles and swings his dead shark and giant cutlass around, slaying all in his wake.

2 Leave the eye-patch out for now, instead concentrating on the other details. Rather than starting with a white background, roughly paint in some texture in the background using conté pencils. This is an excellent aid for helping paint warm flesh tones quickly as it gives you a good base colour to work from.

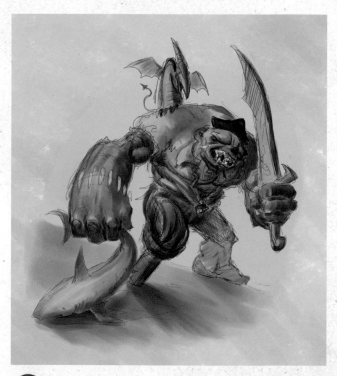

1 Peg-legs and eye-patches just have to be included in an ogre pirate image. Draw Clodhopper leaning to the side, cutlass and dead shark in hand, Nibbles on his shoulder and looking mightily smug with himself.

3 Wash in some flat colours, making the sky a nice clear blue, giving Clodhopper some bright striped pirate pantaloons and filling in some tones on his flesh. Leave his trailing leg lightly painted as this will be washed out. The light is coming in from the left side, so paint in the shadows accordingly in a grey-green colour.

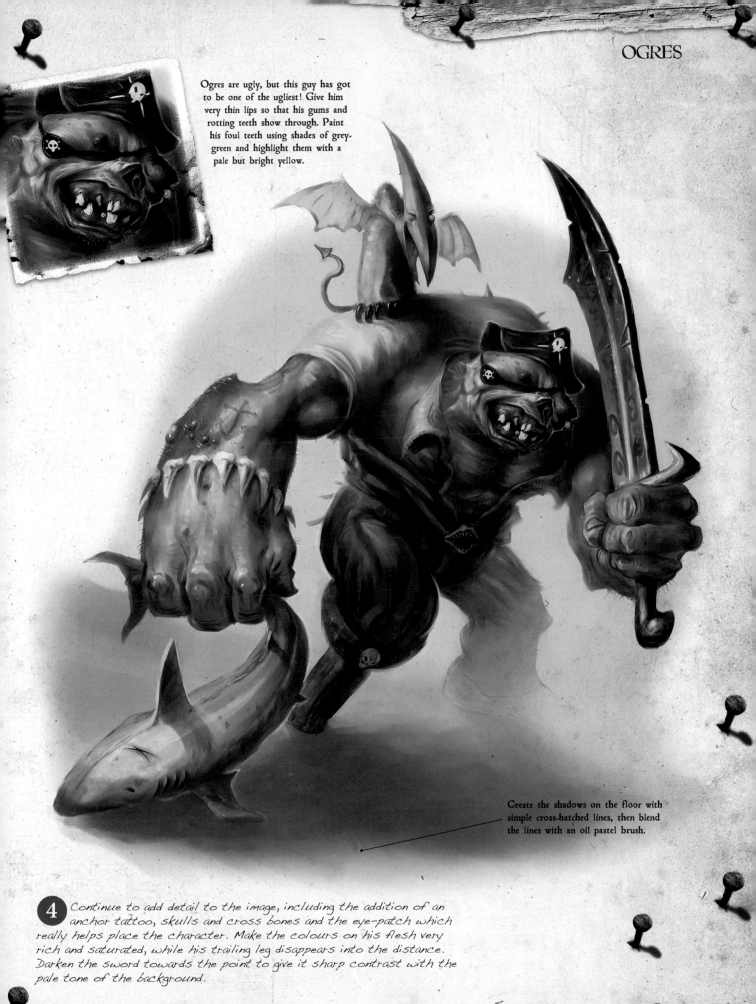

Ogres are ugly, but this guy has got to be one of the ugliest! Give him very thin lips so that his gums and rotting teeth show through. Paint his foul teeth using shades of grey-green and highlight them with a pale but bright yellow.

Create the shadows on the floor with simple cross-hatched lines, then blend the lines with an oil pastel brush.

4 Continue to add detail to the image, including the addition of an anchor tattoo, skulls and cross bones and the eye-patch which really helps place the character. Make the colours on his flesh very rich and saturated, while his trailing leg disappears into the distance. Darken the sword towards the point to give it sharp contrast with the pale tone of the background.

pet handler

Nimal Willkeel

Nimal is the chief pet handler on the battlefield, commanding and beating poor creatures to do as he wishes. Sending them out to their deaths in this manner is great fun for him but the poor beasts aren't sure what's better, dying at the hands of Nimal or dying in combat.

He doesn't really have any skills at training or befriending animals, he just tortures them until he has broken their will so they learn to do as he commands.

He's a wicked and spiteful creature, who drools at the chance to ram a hot poker into the side of a poor defenceless animal. He's quite happy to kill them off if only for an excuse to hunt down and torture another. Here, we see a rare example of an animal getting the better of him and dragging him for a mile long run.

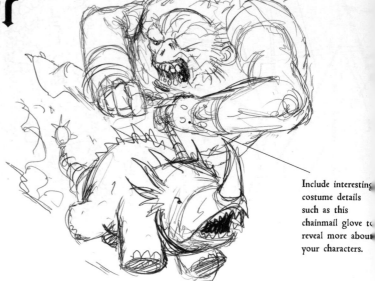

Include interesting costume details such as this chainmail glove to reveal more about your characters.

2 Refine your sketch all over, paying particular attention to Nimal's furious expression. As he is known for using hot pokers give him a chainmail glove. Think about having dust and smoke blowing up from the rear of the animal and indicate this with a few squiggles.

1 Why not give the pet a chance in your image, so show him charging towards the viewer with Nimal angrily holding on for dear life.

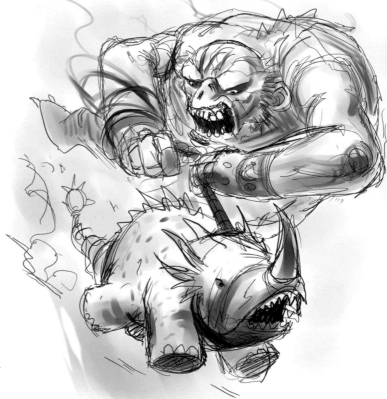

3 Paint in the initial tones, with the focus being on Nimal's front arm and face and the animal's face. To help draw attention to these areas, Nimal's far arm and leg will need to be slightly blurred in the final image.

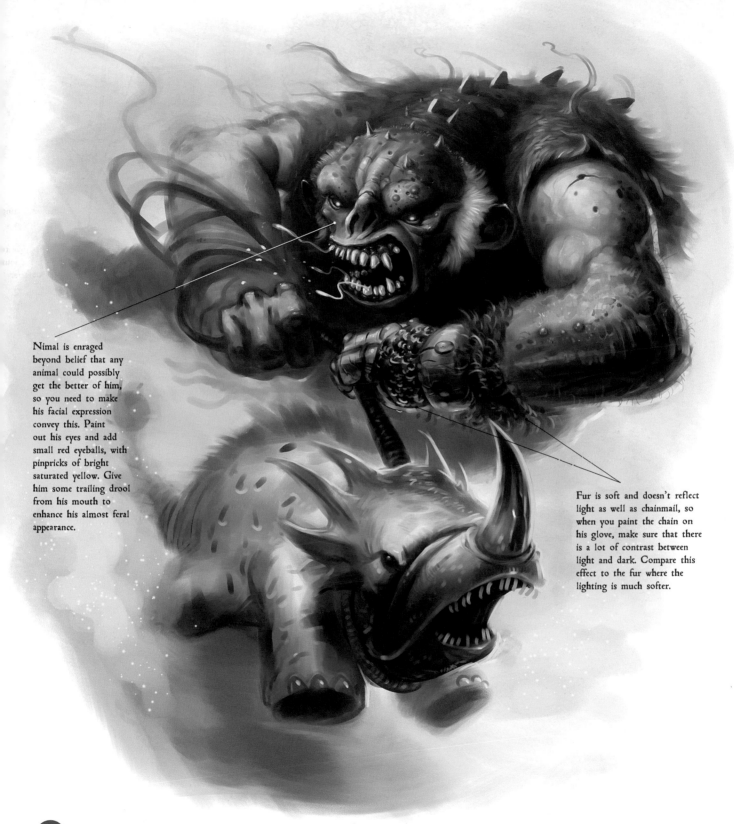

Nimal is enraged beyond belief that any animal could possibly get the better of him, so you need to make his facial expression convey this. Paint out his eyes and add small red eyeballs, with pinpricks of bright saturated yellow. Give him some trailing drool from his mouth to enhance his almost feral appearance.

Fur is soft and doesn't reflect light as well as chainmail, so when you paint the chain on his glove, make sure that there is a lot of contrast between light and dark. Compare this effect to the fur where the lighting is much softer.

4 Work up the detail in the selected areas, then blend the rear of the animal and Nimal's far arm so that they are less detailed and less saturated. Make the animal really stand out from the browns and greys that are around him by giving him a wash of blue/green. Add drool to Nimal's mouth and dust clouds to indicate the direction and pace that they're moving in.

goblinoid keyword creator

This final section takes an idea and turns it into an interactive game to help kick-start the ideas process for your own paintings.

The concept behind each of the following tables is to roll a die; whatever number you roll corresponds to that column in the table. Choose any of the keywords in the column to help create your character. Roll the die for each table until you have a solid list of keywords to get you started.

These tables are here to give you ideas. If you don't want to roll a die and just want to pick and choose from each table, or even use your own keyword, then go ahead – be creative, go wild and most of all have fun!

Race

The six goblinoid races – roll the die to decide what type of character you will be designing.

1	2	3	4	5	6
Goblin	Hobgoblin	Half-orc	Orc	Troll	Ogre

Class/Occupation

Where would your characters be without a job? Nowhere, probably wandering the desert being eaten by vultures, so roll on this table to decide!

1	2	3	4	5	6
Smith	Baker	Butcher	Candlestick maker	Fisherman	Cowboy
Crossbowman	Archer	Nurse	Surgeon	Assassin	Rifleman
Dog handler	Militiaman	Carpenter	Stonemason	Time traveller	Hangman
Necromancer	Engineer	Monk	Knight	Dragon slayer	Santa Claus
Tooth fairy	Dentist	Babysitter	Midwife	Olympiad	Pilot
Fire fighter	Judge	Writer	Map maker	Pig farmer	Astronaut

Skin colour

Who says you have to stick to the skin colours I've suggested? Roll on this table and choose any or all of the colours that you want from the column you rolled.

1	2	3	4	5	6
Yellow	Yellow-green	Green	Blue-green	Blue	Blue-violet
Violet	Red-violet	Red	Red-orange	Orange	Yellow-orange
Black	Grey	White	Pink	Brown	Multicoloured

Skin texture

Roll the die to choose the skin textures your character will have.

1	2	3	4	5	6
Scars	Stitches	Boils	Warts	Sores	Hair
Cracked	Peeling	Oily	Diseased	Sunburnt	Frostbitten
Wrinkly	Smooth	Lumpy	Wet	Rough	Gunshot wound
Gangrene	Knife wound	Bruised	Staples	Clean	Dirty
Tattoos	Warpaint	Make-up	Ringworm	Fungus	Infection
Stubble	Rashes	Raw	Pus	Scabs	Burns

Clothing/Accessories

Roll to add some items to make your character look more interesting or to give it some history and intrigue for the viewer.

1	2	3	4	5	6
Piercings	Wig	Underwear	Trousers	Apron	Shorts
Jodhpurs	Boots	Animal furs / skin	Clogs	Sandals	Gloves
Hats	Belts	Straps	Chains	Rope	Feathers
Feather boa	Skirts	Kilt	Bandages	Pouches	Bottles / flasks
Wine / water skin	Jewellery	Studs	Amulet	Make-up bag	Scarves
Bones	Skulls	Shrunken heads	Satchel	Backpack	Binoculars
Telescope	Whip	Shovel	Compass	Badges	Emblem / insignia
Symbols	Maps	Potions	Teeth	Body parts	Crystal ball
Skis	Roller skates	Ice skates	Spikes	Patches	Cigar
Smoking pipe	Dog tags	Comb / brush	Coat / jacket	Shirt	Jumper
Torch	Helmet	Cloak	Robe	Hood	Clocks / watches
Musical instruments	Bandana	Animals	Glasses	Monocle	Manacles
Wedding attire	Maids uniform	Slippers	Nappy	Socks / stockings / tights	Cooking equipment
Stuffed animals	Camping equipment	Umbrella	Ceramics / pottery	Leg warmers	Tie

Weapons/Armour

It's a dangerous world out there, your characters must be armed! Roll and keep them alive.

1	2	3	4	5	6
Machete	Bullets	Holster	Dagger	Sword	Knife
Throwing knives	Darts	Chainsaw	Shovel	Shotgun	Scalemail
Chain-mail	Leather	Ringmail	Plate armour	Dragonscale mail	Ball and chain
Hand-axe	Shurikens	Bow and arrows	Spear	Crossbow	Slingshot
Club	Stones / rocks	Mace	Morning star	Cat o' nine tails	Wand
Staff	Rifle	Machine gun	Flame thrower	Cannon	Pistols
Pike	Stake	Whip	Knuckle dusters	Throwing spikes	Spikes
Studs	Bullet belt	Tree stump	Hot poker	Torch	Stick
Poison	Syringe	Saw	Scissors	Shears	Scalpel
Long sword	Short sword	Broad sword	Samurai sword	Battle axe	Head gear

GOBLINOID KEYWORD CREATOR

Mood/Characteristics

Here is a table of keywords that can influence the pose and expression of your character. Which column will you land in?

1	2	3	4	5	6
Happy	Sad	Angry	Grumpy	Surprised	Afraid
Aggressive	Excited	Cheeky	Resourceful	Timid	Daring
Adventurous	Tired	Sneezy	Sickly	Healthy	Crafty
Sly	Evil	Nasty	Good	Angelic	Helpful
Determined	Stupid	Gormless	Conniving	Heroic	Cowardly

Quirks

Does your character have something unusual about him or her? Roll on this table to find out what it is.

1	2	3	4	5	6
No teeth	Discoloured teeth	Peg leg	One eye	Wings	Bird feet
Three arms	Two heads	Eye patch	One arm	Extra eyes	Amputations
Undead	Horns / extra horns	Scales	Tail	Hunchback	Webbed hands / feet
Shrivelled limb	Crab claw	Fish tail	Feathers	Overly large head	Tiny head

about the author

Scott's first time trying to contact the goblinoids!

Scott Purdy is a freelance illustrator working in a number of different industries, including book publishing, role-playing games and collectable card games. His chief love is fantasy art, especially if there are gobliniods involved. His clients include Fantasy Flight Games, Green Ronin and Malhavoc Press. He lives peacefully and happily on the south coast of England with his goblinoid family, selling gambogle dung to anyone who is daft enough to buy it. For more information and further examples of Scott's work, visit **www.scottpurdy.net**

acknowledgments

I would like to thank Freya, Martin, Emily, Ame and everyone at D&C for sticking by me through hard times. Monster Island, you played your part too, thanks guys :)

index